Afterglow in the Desert
The Art of Fernand Lungren

Elizabeth A. Brown

with an essay by Jane Dini

University Art Museum University of California, Santa Barbara

Distributed by University of Washington Press Seattle and London

Exhibition Itinerary

University Art Museum
University of California, Santa Barbara
May 2 – July 9, 2000

The Laguna Art Museum
Laguna Beach, California
January 20 – March 24, 2001

Palm Springs Desert Museum
Palm Springs, California
April 11 – June 10, 2001

Lenders to the Exhibition

Bob and Marlene Veloz

Santa Barbara Museum of Natural History

Santa Barbara Museum of Art

Kennedy Galleries, New York

Spanierman Gallery LLC, New York City

Exhibition support has been provided in part by the California Arts Council, a state agency, Patricia and Charles Cleek, Joseph and Marjorie Shipp, and Howard and Jean Fenton.

Major conservation support was provided by a generous grant from Bob and Marlene Veloz.

Treatment of individual works has been sponsored by Gary Breitweiser, Deanna and James Dehlsen, Eva and Yoel Haller, and Joseph and Helene Pollock.

UNIVERSITY ART MUSEUM
University of California, Santa Barbara

2

Table of Contents

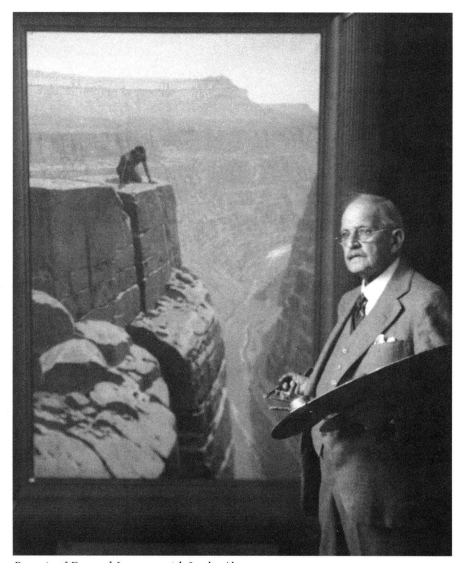

Portrait of Fernand Lungren with In the Abyss
Cat. no. 74

4

Foreword

Fernand Harvey Lungren (1857–1932) is Santa Barbara's most distinguished early 20th century artist. A premier painter of the American Southwest, he is best known for his images of the desert and his remarkable use of color to capture the grandeur and variety of the region's landscape. The first-ever retrospective of Fernand Lungren's career was planned to coincide with the reopening of the University Art Museum in May 2000 after a two-year closure for major renovation, which included the addition of a dramatic new entrance and adjoining plaza and the total redesign of the interior space. One of the primary objectives of this project was to create better opportunities for the Museum to showcase its permanent collections, most of which, like those of other museums, remains in storage. Four of our six new state-of-the-art galleries are dedicated to showing permanent collections (three on a regularly changing basis) and two will showcase special exhibitions. More of our diverse and eclectic collections, from important Renaissance materials to the most cutting edge contemporary art, can now be put on regular view. Upon the reopening of the Museum, it seemed fitting to bring to the attention of our campus and community audiences one of its founding collections—the Fernand Lungren Bequest—and thereby celebrate the artist's little-known and undervalued career at the very moment the Museum itself is celebrating its new and enhanced visibility and identity.

In his later years, Lungren assembled a core group of paintings and works on paper meant to represent his life's work, which he bequeathed to the "people of Santa Barbara" in 1932. By the terms of his will, this substantial body of approximately 188 paintings and 131 drawings went to the Santa Barbara Teachers' College, which later became the University of California, Santa Barbara. In 1964, after 32 years of uncertain care and exposure, this substantial collection found a home at the five-year-old University Art Galleries at UCSB, where it could be stored responsibly and handled professionally.

It is because of the accidents and vagaries of institutional history as well as the trends and fashions of art history and criticism that it has taken another 32 plus years for this significant collection to receive its due through a major retrospective exhibition and a scholarly monograph. Most of Lungren's works have suffered from the artist's use of unstable commercial materials and his unsuccessful technical experimentation. Other damage occurred while the collection was still in his studio, caused by the devastating Santa Barbara earthquake of 1925. Hence an intensive conservation effort has long been needed. The Museum stabilized many of Lungren's paintings during the 1970s and 1980s, but it was not until the past few years that major conservation

treatment could be done to restore a core group of works to their intended appearance and to an exhibitable condition.

The 1990s was a decade marked by a renewed interest in 20th century California landscape art. Lungren's place within this history has never been secured, largely because his oeuvre remained largely unpublished and not easily accessible for research. Not exhibiting or selling his work much during the final decades of his life helped encourage his relative invisibility and absence from the historical record. Having the bulk of his life's work as part of our Museum collection has placed the burden on us to establish his historical role and position. The reconstruction of his career and chronology has been very difficult for several reasons: Lungren left little documentation (and much of what he did leave appears to have been lost); he chose not to date the majority of the landscapes he painted while living in Santa Barbara; and almost no sales or exhibition records exist. It has taken the commitment of the current University Art Museum staff and our association with a major research university to meet the challenges of restoring Fernand Lungren to art history. Although he is known to a small cadre of specialists, and individual works have been included in several exhibitions and catalogues, this is the artist's first comprehensive scholarly treatment.

Elizabeth Brown, the Museum's Chief Curator, has been interested in the enigmatic Lungren since she arrived in 1992. The paucity of information on Lungren relative to his prodigious output made him a compelling art historical subject. In winter 1997, Brown, in collaboration with Bruce Robertson, specialist in American art and Professor in the Department of the History of Art and Architecture, offered a graduate seminar designed to begin the research process on Lungren. Several months earlier, the Santa Barbara Museum of Art (SBMA) had opened the exhibition *The Painters Paradise*, which focused on California landscape art and included four Lungren canvases. Not only did the exhibition help put Lungren's work within the context of other California painters, it provided an opportunity for us to meet Bob Veloz, a patron of the SBMA and major sponsor of *The Painters Paradise* as well as an avid collector of and advocate for California landscape art. We are grateful to Robert Henning, Assistant Director for Curatorial Services at the Museum, for facilitating Mr. Veloz's introduction to the scope of our Lungren collection. It was because of Bob and Marlene Veloz's generous support that we were able to conserve a core group of Lungren paintings and thereby make a retrospective exhibition possible.

The Museum wishes to thank Jane Dini, a student of Robertson's and recent UCSB Ph.D., who has solved some of the scholarly mysteries and has put Lungren's career development within the context of early 20th

6

century American art. We are grateful to her for uncovering invaluable new source materials and using them wisely to interpret specific works and locales for Lungren's paintings. Cody Hartley, UCSB graduate student and Museum Curatorial Assistant, also furthered the research effort and has assembled as comprehensive a chronology as can now be reconstructed. Moreover, he has done a masterful job of coordinating a myriad of administrative details concerning the project. We thank them both for their diligence and dedication.

Elizabeth Brown deserves the institution's deep gratitude for making a commitment to seeing the Lungren Bequest receive the attention it has long deserved and needed. The paintings' fragile condition and the significant funds required for their restoration were of primary concern. In addition to overseeing the conservation of 47 paintings and works on paper, she supervised all aspects of the exhibition and publication, and conducted extensive original research on the artist. As a specialist in early 20th century European art history, she has brought to the project a special understanding of Lungren's relationship to international art historical developments. Her hope, as well as mine, is that with the publication of this monograph and the circulation of the exhibition, further interest will be generated in the artist and new information will come to light to expand our first efforts in interpreting his career and its context.

The entire University Art Museum staff has collaborated in the recuperation of Fernand Lungren. It has been an ambitious undertaking on many fronts, and the talents and professionalism of all concerned has assured the Lungren Bequest the best care and presentation.

Again, our thanks go to Bob and Marlene Veloz for their generous support of essential conservation treatment as well as to Gary Breitweiser, Deanna and James Dehlsen, Eva and Yoel Haller, and Joseph and Helene Pollock for their assistance. Additional exhibition support has been provided by the California Arts Council, a state agency, Patricia and Charles Cleek, Joseph and Marjorie Shipp, and Howard and Jean Fenton.

With the publication of this catalogue we hope to make richer and more meaningful the gift of art Fernand Lungren made to the people of Santa Barbara in 1932. Lungren's legacy is being maintained today by many Santa Barbara artists equally committed to portraying the beauty of our environment. Like him, they believe in the importance of its preservation, and in the power of visual representation to remind us of what nature can and should be. We hope this book, which traces through glorious color reproductions Lungren's sun-drenched and windswept vistas of the American West, helps us remember that our responsibility lies in the conservation of both objects and subjects.

Marla C. Berns
Director

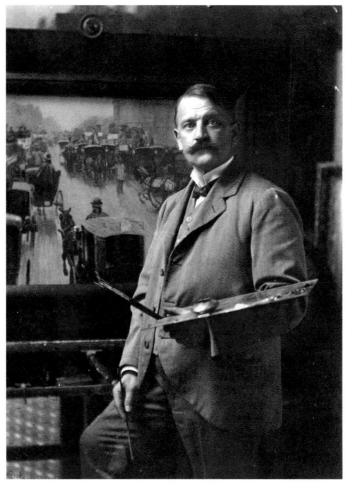

Fernand Lungren in London with Arm of the Law
Cat. no. 68

8

Acknowledgments

The Lungren Bequest is more than just a collection of work by an interesting and undervalued artist. It also raises fascinating issues related to early 20th century American art, and more particularly to the artistic community of Santa Barbara. As a curator specializing in modern and contemporary art and as a historian of 19th and early 20th century American art, we sought precisely such an opportunity to combine our perspectives, to volley ideas back and forth, and to explore the pedagogical potential of the Museum collections. Our first thanks are to each other and to this academic community, where such collaborations are valued and supported.

Fernand Lungren's work is marked by extraordinarily delicate surfaces. That the majority of them survive intact is due very largely to the fact that they have not been exposed and cleaned, circulated and varnished, glossied up for the market. Instead they awaited the careful and informed efforts of talented conservators. We are exceptionally grateful to the individuals who made it possible to restore Lungren's work to its intended appearance: to Bob and Marlene Veloz for sponsoring the primary conservation of over 30 paintings and to the three studios who coaxed the truth out of complicated surfaces—Travers Newton; Denise Domergue and Conservation of Paintings, Ltd.; and Robert Aitchison, Lisa Forman, and Mark Watters of Aitchison & Watters. We also thank the individuals who "adopted" drawings and paintings by underwriting their treatment.

This exhibition grows out of groundbreaking work in a graduate seminar that we team-taught in 1997. For their thoughtful questions about the significance of Lungren's work, as well as the initial answers their research provided, we are deeply beholden to the seminar participants: Nancy Arnold, Denise Baxter, Melinda McCurdy, Michelle Russell, and Caroline Smith.

Jane Dini, whose research discovered Lungren within the context of his friendships as well as his artistic circle, and who produced the moving and insightful essay at the center of this catalogue, earned her doctorate from the University in 1998. We are delighted and grateful for the marvelous work she has done on the subject of Fernand Lungren as an early American artist.

In drawing on the intellectual resources of the University, we have also been assisted by a series of superb graduate assistants. Over the past year Cody J. Hartley, the current Curatorial Assistant, has devoted considerable insight and passion to the project. His extensive research assistance, attention to organizational details of the exhibition from the tour to the publicity, and grace under pressure have been indispensable to its realization. From 1996 through 1998 Melinda McCurdy, the previous Curatorial Assistant, worked intensely on the early planning and research and contributed to the final product in more ways than we can count. Andy Lohr and several undergraduate interns also provided research and administrative assistance.

Although the core of the exhibition comprises 61 works from the Lungren Bequest to the University Art Museum, it has benefited enormously from strategic additions made possible by generous and understanding lenders. We are deeply grateful to Kennedy Galleries, Spanierman Gallery, the Santa Barbara Museum of Art, the Santa Barbara Natural History Museum, and Bob and Marlene Veloz for generously agreeing to lend paintings and objects from their collections. Special thanks to Gregory Hedberg and Arlene Nichols of Hirschl & Adler Galleries; Lillian Brenwasser of Kennedy Galleries; Ellery Kurtz of Spanierman Gallery LLC; Robert Henning, Karen Sinsheimer, and Marshall Price of the Santa Barbara Museum of Art; and Jan Timbrook, Department of Anthropology, and Terri Sheridan, Library, at the Santa Barbara Natural History Museum.

A central goal of this exhibition is to introduce Lungren's work to a broader audience. We are thrilled that the exhibition will be presented at two distinguished California institutions and most grateful to the colleagues who helped make it possible: Bolton Colburn, Director, and Tyler Stallings, Curator of Exhibitions, The Laguna Art Museum; Janice Lyle, Executive Director, and Katherine Plake Hough, Director of Collections and Exhibitions, Palm Springs Desert Museum.

As always, numerous individuals provided crucial assistance behind the scenes. Sarah Vedder in particular generously contributed time, ideas, and artistry to making this exhibition possible. Hank Pitcher and Michael Drury also provided important assistance. We acknowledge the research support of the UCSB Library, particularly Special Collections, Inter-Library Loan, and the Arts Library. Thanks are also due Michael Redmon of the Santa Barbara Historical Museum; Laurie Wagner, *Harper's Magazine*; Joanne Herndon, Springville Museum of Art; Amy Verone, Sagamore Hill National Historic Site; Olivia Flisher, Santa Barbara Public Library; and the personnel of Death Valley National Park for help with research questions.

If any project involved the entire staff of a museum, it was this one. The personnel of the University Art Museum has contributed enormous energy and dedication to the Lungren exhibition in specific, and to the reopening in general. Sandy Rushing, Registrar, has been an equal partner in organizing the conservation, as well as in helping to make sense of the oeuvre. She was ably assisted by assistant registrars Jessica Reichman, Stephanie Semler, and Kerry Tomlinson. Paul Prince, Designer, brought deep familiarity with Lungren's work along with the extraordinary ingenuity and flair that is his norm to the presentation and installation of the work, with the collaboration of Rollin Fortier, Preparator. Marla Berns, Director, had the insight of having this exhibition mark the reopening of the redesigned Museum. We are always dependent on her close readings and deep insights; her participation in this project cannot be overstated. Peggy Dahl, Assistant to the Director, and Vicki Stuber, Business Manager, provided important support throughout the project; Vicki Allen has assembled effective publicity, based in part on initial concepts from Sharon Major. Hallie Anderson, Outreach Coordinator, and Kurt Helfrich, Curator of the Architecture and Design Collection, also helped in many ways.

Philip Koplin is a marvelous editor, endlessly informed, highly responsive and ingenious, as well as gentle. We are deeply indebted to Ginny Brush of Brush & Associates for a gorgeous catalogue that transforms numerous difficulties into an elegant and appropriate design. Their collaborations are felt on every page.

Elizabeth A. Brown
Chief Curator, University Art Museum

Bruce Robertson
*Professor, Department of the
History of Art & Architecture*

University of California, Santa Barbara

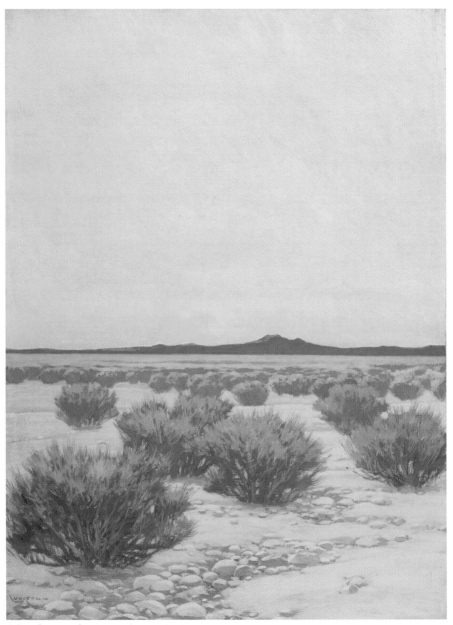

Afterglow in the Desert
Cat. no. 59

Afterglow in the Desert

Fernand Lungren's bequest to the city and people of Santa Barbara consists of approximately 320 paintings and drawings representing most of the phases of his artistic career. The Santa Barbara State Teacher's College (as it was then called)[1] was charged with preserving all the pictures then in his "studio and art gallery" as a permanent exhibition "to be open to the public under such proper restrictions and at such suitable times as are customarily provided for such exhibitions." The artist explained his intentions with characteristic modesty:

> As my artistic efforts seem to have given a large number of people considerable interest and pleasure, the expression of which by them has been a great source of happiness to me, it has seemed well…to preserve in one group those pictures remaining in my studio and gallery to be held permanently for the use of the people of the City of Santa Barbara and its vicinity, in memory of my wife and myself, in appreciation of the happiness we found in this community, and with the hope that this provision will result in as much pleasure to the community as I have in making it.[2]

Three general points are of note with regard to the bequest. First, Lungren shaped this group of paintings and drawings to provide the basis for a museum. Second, he saw his art as inspiration for the growth of a community of artists in Santa Barbara. Finally, he directed the legacy to the largest humanities institution of the time in Santa Barbara, the local college, which ultimately became the University of California at Santa Barbara.[3]

Lungren's bequest became one of the first collections to be processed upon the founding of the University Art Galleries at UCSB (later to be named the University Art Museum). An impetus for forming a collection came from the Francis Minturn Sedgwick gift of 1960, 20 Old Master paintings including important works by Gerard David, Juan de Flandes, and Jacob van Ruisdael, donated with the explicit goal of prompting the formation of a university museum "comparable to the FitzWilliam Museum at Cambridge and the Fogg Museum at Harvard."[4] In 1964, University officials and community supporters worked together to acquire the Sigmund Morgenroth collection of 436 Renaissance medals and plaquettes. This important acquisition together with the Lungren bequest and other major gifts helped establish the Museum as a collecting institution.

My first exposure to Lungren came with the collection inventory of 1993. On that occasion all of the paintings were removed from the vault and I had the opportunity to view a surprising number of similar desert scenes and other

landscapes. I saw numerous accomplished canvases done both early and late in the artist's career. At the same time, many of the 188 paintings were unfinished: some were nearly resolved except for one or two areas, others had been abandoned midstream. There were nearly 50 oil sketches, studies painted on site, of cactus (cat. no. 49), snow flurries (cat. nos. 46–47), rolling clouds (cat. no. 42), and other visual phenomena. Numerous objects were damaged. Tears and losses disfigured some of the most beautiful scenes. In some cases large areas of paint had lifted off the canvas and were in imminent danger. All of the paintings needed cleaning; many had the characteristic brownish yellow surface that reflects decades of smoke-filled rooms. But they were compelling nonetheless, from the attractive and well-observed views of the high Sierra to the occasional seascape.

What I found most impressive were some of the desert landscapes. Many of them seemed highly consistent in composition—a low-slung horizon, minimal details of sage brush, creosote, or other desert shrubs in the foreground, and perhaps a crenellated mesa in the distance. They also exhibited a remarkable palette. In contrast to the realism of Lungren's mountain lake pictures, for example, or the cityscapes (which turned out to be "early work"), these desert paintings abandoned local color, i.e., the hues we know to be present. Many were painted in variations of cerulean, ultramarine, and other blues, others pictured the sky as pale yellow and the ground in tones of violet. The most striking to me was and remains *Sands of Silence* (cat. no. 45), a mauve monochrome with virtually no "incident": just gradual horizontal bands of shifting tones, suggesting the patterning of light and shadow in variations of pinks and purples. Here was an artist who occasionally approached abstraction. He also came very close to working in series, where several paintings use the same composition and vary only by a controlled factor, such as the coloristic effects of a specific time of day or meteorological event. Series and monochromes were two of the formal categories signifying the avant-garde in other areas of the world during the first three decades of the 20th century, the period when Lungren produced these undated canvases. Yet there is no evidence in the meager surviving documentation that Lungren had any consciousness of art being shown in New York or Paris in the early years of the 20th century.

Nearly all of the written information available on Lungren derives from a biography by John A. Berger, published in 1936. The Foreword was by Stewart Edward White, a prolific writer on Western themes and Lungren's first friend in Santa Barbara. About Berger little is known: he turns up elsewhere as "Registrar of the Santa Barbara School of the Arts," a community organization that Lungren had helped to found in his efforts to strengthen the cultural community in Santa Barbara. Berger's enthusiastic chronicle of the artist's life at times verges on hagiography, but if we discount the stylistic flourishes of biography at the time, he provides considerable infor-

mation evidently gleaned from Lungren himself as well as his circle. Berger seems also to have had notebooks and other documents at his disposal that are now lost.[5]

Lungren's path is an interesting one, following patterns characteristic of American art at the turn of the last century. The first was the burning desire to become an artist, and his difficulty in finding a way to do so. Dropping out of the mining engineering program at the University of Michigan at the age of 20, he traced a path from Toledo, where his family lived, to Cincinnati, where he encountered the young artist Robert Blum, then followed Blum to Philadelphia, in search of a community he could join. Jane Dini's essay in this catalogue ably chronicles the young artist's development, his formation of a circle of associates, and his relationship to the broader developments in American art between 1880 and 1900. Of particular interest are the myriad artists he knew and the numerous contexts in which he was active. He worked alongside an eclectic but star-studded list of the artists of the period, including Thomas Eakins, Childe Hassam, William Merritt Chase, and James A. McNeill Whistler. Working for *Scribner's Monthly*, *Century Magazine*, and other periodicals, he became a significant figure in the Golden Age of illustration, the period when artistic activity found a new mass audience in America. He visited

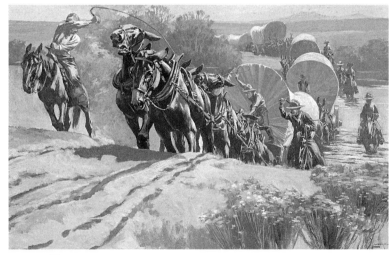

Wagon Train
Cat. no. 35

Paris in 1882–1884 as a fledgling artist. He spent three years in London in 1899–1901 as an accomplished artist, and was welcomed into the circle around Whistler. Striking opportunities offered him new vistas. As one of the first group of artists sent along the routes of the Santa Fe Railroad, beginning in 1892 and continuing through 1897, he was exposed to the dramatic landscapes of the Southwest, and found an immediate audience for this subject. In London in 1900 Henry Wellcome invited Lungren and his wife, Henrietta, to join his expedition to Egypt. Finally, moving to the West Coast at the beginning of the 20th century, he focused on a unique goal of depicting the mysteries of the Southwest desert.[6]

In 1876 Lungren enrolled briefly at the Pennsylvania Academy of the Fine Arts, where he would have been exposed to the aesthetic and pedagogical techniques of Thomas Eakins. This was one of two very truncated experiences with arts education; Lungren also studied very briefly at the Académie Julian in Paris, leaving because he had no interest in drawing from plaster casts. Instead the artist was largely self-taught, which led both to shortcomings—such as his difficulty with drawing people and animals—and advantageous freedom from "academic" standards and cliches. From the early 1880s through the turn of the century, Lungren experimented somewhat briskly with a range of subjects and styles: American Impressionism á la Childe Hassam; realist cityscapes of New York, much of them redolent of his magazine illustrations; and Western scenes—both landscapes and genre images of Southwest Indian life—comparable to his contemporary Frederick Remington, who like Lungren was supporting his painting with magazine illustrations. Whereas Remington focused on the figures of men and horses, using his Yale training in anatomy to construct highly dramatic narratives, Lungren's interest always centered on the landscape.

Magazine illustration work had a major effect on Lungren's development. The first publication he illustrated was "Fortunes and Misfortunes of Company 'C'," in the February 1879 *Scribner's Monthly*. Later that year he

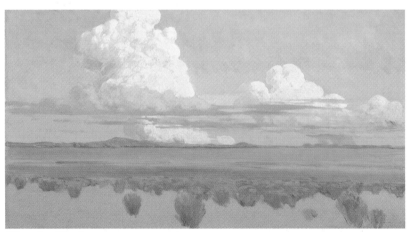

Thunder Heads
Cat. no. 43

contributed images to another article in *Scribner's* as well as two for *St. Nicholas*, a children's periodical published by the same company, and continued to work steadily for those two journals for the next of couple years. After his first trip to Europe, he resumed working for *St. Nicholas*, where he was represented nearly every year between 1886 and 1904, as well as *Century Magazine*, appearing in 14 or more issues between 1884 and 1903. Alexander W. Drake, considered a prime mover in the growth of magazines in the last quarter of the 19th century, was art editor of *Century, Scribner's,* and *St. Nicholas*. Under his direction Lungren produced a bewildering array of subjects,

from soldiers to fairy-tale royal courts, from fanciful histories of Handel, Lafayette, and Peter the Great, to investigative observations of an old Virginia town and New York City slums. This experience taught him how to take on nearly any subject. In contrast, it is not clear how long Lungren studied at the Pennsylvania Academy or how close his association was with Eakins. Perhaps Lungren's deployment of gritty details as in "Shantytown," published in the October 1880 *Scribner's*, reflects his Pennsylvania Academy experience.

Lungren's illustrations for periodicals where Drake did not work have more consistency in style and focus. When he began to contribute to *Harper's Magazine*, and later *McClure's Magazine* and *The Outlook*, he was an established artist with a specialization in the American West. Unlike the eclectic themes of his work for *Scribner's*, *St. Nicholas*, and *Century*, these later illustrations draw on Lungren's specific expertise in the geology and cultures of the West. Moreover, the commissions might have resulted from his close associations with the authors of the articles, including Charles F. Lummis, Stewart Edward White, and William Allen White.

Another decisive experience was his (probably marginal) association with the Tile Club, a playful and obstreperous group of vanguard artists including Chase, J. Alden Weir, and Elihu Vedder. Judging from the numerous plates in *A Book of the Tile Club*, there is no indication that even his friend Blum was a true member of the Club, which "restricted their roll-call to a specified and very small number."[7] However, Lungren and Blum were included in a Tile Club expedition to Europe in 1882 and shared a cabin. The trip itself is amusingly recounted in "Log of an Ocean Studio," written by Clarence Clough Buel for *Century Magazine*, January 1884.[8] The stated goal was to go and hate the Paris Salon. Lungren is referred to as the "nightmare painter, for his gloomy rain scenes." His insistence on painting the hellish vision of men stoking the ship's furnaces contrasts dramatically with the bourgeois subjects he painted in Paris and the politically neutral work he sought later in his life.

Despite the commitment of the jolly travelers to revile the new art in Paris, Impressionism seems to have penetrated Lungren's skin. During this two-year sojourn he produced several works that deserve to be called American Impressionism. Only one, *The Gardens of Luxembourg* (cat. no. 2), is included in the present exhibition.[9] No reflection of this body of work exists in the Lungren bequest, perhaps the only major development of Lungren's career so excluded. One reason might be that these works sold easily. The small number of recorded activities during and after this trip suggests that Lungren might have been selling enough works to

support himself. By the mid-1880s there was a strong market for such images of glamorous, lyrical Parisian life as *Woman in a Cafe* (see Dini, pp. 30–31), a painting listed as belonging to Childe Hassam and now in the collection of the Art Institute of Chicago, and *Lady Reclining on a Sofa*, which Dini analyzes in relation to Whistler and which also speaks of a debt to Tissot. *Paris Street Scene* (Terra Foundation for the Arts) attests to the influence of Gustave Caillebotte, whose realist paintings were perhaps more accessible than work of Monet or other artists Lungren encountered in Paris in the early 1880s.

There is no record of how many "Impressionist" paintings Lungren produced, of their critical reception, or how they were sold. The question of how this experience influenced Lungren's subsequent work is hard to answer. For example, it is difficult to discern any difference in his illustrations before and after that trip. This could, however, have as much to do with his lack of seniority among the illustrators and the financial necessity of pleasing his editors as with any personal choices. Numerous elements that might reflect the influence of Lungren's two years in Paris surface considerably later. One of the crucial elements of French Impressionism is its reduction of motifs to visual sensation, expressed in discrete touches of paint whose effects combine optically in the eye and mind of the viewer. The Impressionists reveled in distinct climatic conditions, such as rain or fog, in part because they provided a denser fabric of atmosphere. This is a lesson to which Lungren returned 15 years later, exploring the transformative atmosphere of dense precipitation in London between 1899 and 1901. Other such aspects of French Impressionism emerge in Lungren's late work, such as the employment of chromatic phenomena or the use of series.

In fact, the most important influence on Lungren's later style derives less from any artworld experience than from a far more mundane source: the marketing strategy adopted by U.S. railroad companies in the early 1890s. On the verge of bankruptcy, the Santa Fe Railroad made a pitch for tourism of the West. As government geologists and other experts were sent to survey the 40th Parallel, the Great Plains, and the Grand Canyon in the 1850s and 1860s,[10] now tourists seeking new experiences were to be induced to follow their tracks. Beginning in 1892, the Santa Fe Railroad offered artists free tickets, food, and lodging in return for paintings and drawings it could use in its marketing campaigns. Between 1892 and 1897 Lungren made annual trips to the region, one of the first artists sent by the Railway. His initial visit centered on the Grand Canyon, which he might have known from John Wesley Powell's 1872 expedition, photographed by John Hillers, and published in *Tertiary History of the Grand Canon District with Atlas*, 1882.[11] Overwhelmed by the vast scale and majesty of the natural formation, Lungren made it the focus of many works, particularly *In the Abyss* (cat. no. 7), which is

in form and scale clearly a painting intended for major exhibitions. Some of the images he created of the Canyon trip were published in an 1893 guidebook on the site, alongside paintings by Thomas Moran.[12]

In subsequent years, Lungren focused on the indigenous peoples of the Southwest. With the help of ethnologists J. Walter Fewkes and A.M. Stephen, he succeeded in gaining entry to the sacred and highly restricted Hopi Snake Dance. Lungren began working on images of the Snake Dance in 1893 and illustrated an 1896 *Harper's Weekly* article on the ceremony. His watercolors *Dance Court, Walpi* (cat. no. 9) and *Yellow Blanket* (cat. no. 8) are studies for a monumental painting he showed, unfinished, in 1898. *The Snake Dance* canvas, which at 7 by 12 feet vastly outscales any of his work other than his backdrops for dioramas, did not appear in the initial transfer of Lungren's bequest. It was gifted by John McGowan of Santa Barbara in 1984, 20 years after the "permanent collection" officially entered the University Art Museum. Because of its partial completion and fragile state of preservation, the *Snake Dance* cannot be shown in the current exhibition.

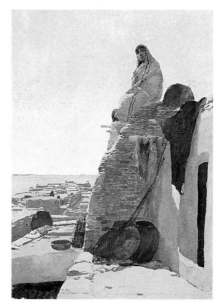

Yellow Blanket
Cat. no. 8

Dini also covers Lungren's Southwest experiences in some depth. What is hard to convey is how distinctive, even earth-shattering these annual trips from 1892 through 1897 must have been. On his very first voyage Lungren visited the Grand Canyon. The 1893 guidebook by C. A. Higgins (to which Lungren contributed illustrations) establishes the challenge of capturing this visual marvel:

> The terrific deeps that part the walls of hundreds of castles and turrets of mountainous bulk will be apprehended mainly through the memory of upward looks from the bottom, while towers and obstructions and yawning fissures that were deemed events of the trail will be wholly indistinguishable....for the panorama is the real over-mastering charm. It is never twice the same. Although you think you have spelt out every temple and peak and escarpment, as the angle of sunlight changes there begins a ghostly advance of colossal forms from the farther side, and what you had taken to be the ultimate wall is seen to be made up of still other isolated sculptures, revealed now for the first time by silhouetting shadows. The scene incessantly changes, flushing and fading, advancing into crystalline clearness, retiring into slumberous haze.[13]

Such visually detailed descriptions of virtual paintings helped to establish Lungren's artistic goals. His many previous styles and subjects suggest a young artist casting around for his focus. It is true that for the next decade he continued to try out different media, subjects, points of view, and cultural associations, and in particular

remained reluctant to give up the figure as subjective focus in his paintings. Yet the seed had been sown for his later immersion in the desert landscape as carrier of his vision.

This first stage of Lungren's experience of the desert Southwest was followed by a three-year sojourn in London that began in 1899 and functioned as a sort of belated and extended honeymoon: he had married the former Henrietta Whipple less than a year earlier. In London she helped to establish social connections to James A. McNeill Whistler, Joseph Pennell, the American Ambassador, and other interesting society. Several of the works Lungren produced in England reveal Whistler's influence. *Rockets* (cat. no. 15) is an overt homage, a mild and peopled version of Whistler's celebrated and notorious *Nocturne in Black and Gold: The Falling Rocket* (1875).[14] Lungren found the British a skeptical audience for his exotic views of the American West.[15] However, his local work seems to have been well received, especially the gloomy scenes for which his Tile Club friends labeled

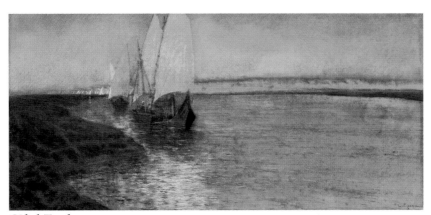

Gebel Turah
Cat. no. 20

him "the nightmare painter." *Liverpool (Docking a Liner)* (cat. no. 14), *The Arm of the Law* (cat. no. 13), and other works in the current exhibition revel in the fog and rain for which England is known. Lungren was accepted as a member of the London Pastel Society, and he used his sojourn to experiment with the medium. The highly finished pastel compositions, such as *Pool and Tower Bridge* (cat. no. 17) and *Earls Court: London* (cat. no. 16), probably represent the kind of work he showed in the second annual Pastel Society Exhibition of 1900. In pastel and oil he developed a more painterly technique, finding atmospheric effects in urban scenes. Thus it is possible that *Piccadilly Slope* (cat. no. 18) and *Passing Train: England* (cat. no. 19) may have been created the following year.

In London Lungren also met Henry Wellcome, pharmacist, entrepreneur, and inventor, who invited the artist and his wife to join his expedition to "the Soudan" (mostly within the boundaries of modern-day Egypt). It is not known whether they participated as social guests or played an official role on the expedition.[16] Upon their

return, Lungren's baggage was ransacked and most of the art he produced in Egypt was lost. The few works that survive from that trip might have been those shipped directly to the 1901 Pastel Society Exhibition, although two are executed in oil (see cat nos. 21 and 22).

According to Berger and supported by Lungren's correspondence with Charles Lummis (founder of the Southwest Museum and a friend of the artist), that experience of the Saharan landscape confirmed the direction of his subsequent work. Back in London, "The call of the desert made itself heard in no uncertain notes, and no attempt at suffocating it would drown the insistent cry."[17] Shortly after returning to the United States, the Lungrens moved to California, living for a few years in Los Angeles near Lummis. In 1906 they purchased land in the Pedregosa Tract of Santa Barbara, just above its famous Mission, and acquired rooms in the Harmer Studio building on De la Guerra Plaza. In 1908 the Lungrens moved into the adobe they built on their land, which still stands near the current Santa Barbara Museum of Natural History.

As early as 1892, when he first visited New Mexico and Arizona, Lungren was entranced by the space, light, geography, and cultures of the West. Now, settled in Santa Barbara, he began traveling regularly until his death in 1932 to the Mojave Desert, Owens Valley, Death Valley, the Sierra, the Grand Canyon, and elsewhere in search of singular vistas. The desert and canyon landscapes that make up the bulk of his oeuvre show his interest in the

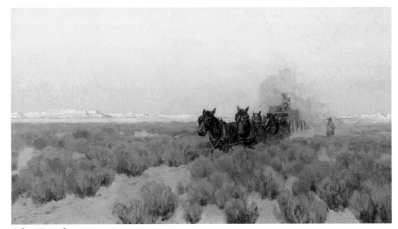

The Freighter
Cat. no. 29

structure of the land and in the remarkable effects of light and climate. Lungren sought to portray the landscape's drama, responding to the changes of times of day and weather as if to the nuances of a personality.[18] After he moved West, Lungren focused on pure landscape. Berger characterizes the shift in heroic terms: "The decision to forsake man for the greater task of portraying nature by itself—not simply its rocks and sands, its peaks and plains, but the inner spirit of their significance to a human being—took courage. He realized that his reputation depended largely upon the human story of his pictures."[19]

Works we might place in the period 1903–1907 trace Lungren testing various solutions for his mature work. *Fifth Street at Hill* (cat. no. 27), circa 1909, is a holdover, representing Los Angeles through the lens of his London street scenes, whereas the pure landscape *Moonrise at the White Mesa* (cat. no. 31), dated 1904, is a harbinger of his future work. I am inclined to date *The Freighter* (cat. no. 29) to the early years of the 20th century as well, by virtue of its extraordinary palette. Although the painting features a stagecoach, and so, as in earlier work, still locates human subjects inside the landscape, in every other way it departs from earlier precedents. The figures—men and horses alike—are delineated in tones of violet; the background mesa is lemon yellow with pink highlights. None of the works that can be dated securely in the 19th century depart this radically from local color. Instead *The Freighter* tries out one of the features that distinguishes Lungren's late work, the daring coloration that allows him to capture extraordinary moments of apperception.

In contrast to the early work, most of Lungren's Santa Barbara oeuvre is undated. His home provided a stable base where he could set up his studio and work as he liked, counting on a support system of beloved wife, friends, and patrons. His working process probably consisted of two separate stages: first, sketching new motifs on site, and second, painting a full-scale canvas back in the studio. It is probably around this time that he began making oil sketches using small stretched canvases or canvas board to paint *en plein air*. On earlier trips, such as the railroad junkets, Lungren seems to have worked often in watercolor. Examples include *Above the Inner Gorge* (cat. no. 4), perhaps painted on one of his first trips to the Grand Canyon, and the first (published) version of *Thirst*.[20] However, the Lungren bequest does not include any watercolors that demand to be dated in the 20th century. Nor are there any pastels that correspond to these pure landscapes, although there are about five (literal) ruins, fragmentary experiments where pastel was layered with oil paint, of which only a few remnants adhere. Thus we have provisionally dated all works in those media earlier. Conversely we assume that most if not all full-scale pure landscapes in oils, the subjects for which Lungren was best known, date around or after his move to Santa Barbara.

Only two of the un-peopled landscapes in this catalogue have dates: *Moonrise at the White Mesa* inscribed 1904 and *Poppies and Lupin* (cat. no. 48) annotated "Antelope Valley 1912." We might be able to link a few paintings to Lungren's first travels as a Californian: in 1903 he made good on his promise to show his wife the desert, touring New Mexico and Arizona to visit the Grand Canyon and the Hopi pueblo at Tusayan. That trip is chronicled by one of their traveling companions, William Allen White, in *McClure's Magazine*; the article included early color reproductions of Lungren's paintings.[21] Lungren's painting of *Canyon de Chelly* (cat. no.

28) probably resulted from that trip, and *Desert Gorge: Calico* (cat. no. 26) resembles some of the published illustrations. On the other hand, some subjects will probably defy all attempts at dating. *Death Valley: Dante's View* could be as early as 1908, the date of Lungren's first trip to that extraordinary desert. It could reflect work on *Death Valley, Sunrise*, which he sold in 1910. It could date from the mid-1920s, when Fred Harvey opened the resorts at Furnace Creek and first began to publicize the site for tourism. Or it could be as late as 1928–29, when the artist completed a monumental canvas of the same scene as a background for the mountain sheep diorama at the Santa Barbara Museum of Natural History. According to Berger, Lungren "…for the rest of his life was working on at least one Death Valley picture," and he records Lungren reworking and completing his large-scale Death Valley paintings at the very end of his life.[22] I believe the same pattern holds true for the expansive desert landscapes he painted, such as *Desert Sand (Evening)* (cat. no. 58) and *Full Moon in the Mojave Desert* (cat. no. 61). They could date from the first or last years Lungren spent in Santa Barbara, from around 1910 or as late as the mid-1920s.

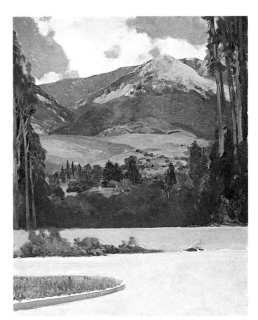

Lungren Home: Mission Canyon
Cat. no. 65

As he investigated the desert Lungren incorporated lessons learned long ago from his visit to Paris in the 1880s; he also continued or resumed compositional devices first used in his figural Western scenes. His omnipresent spherical sage brush foreground appears in such illustrations as the plates for a Western novel by Kirk Munroe,[23] then recurs in the later pure landscapes. Lungren seems to have explored the coloristic lessons of Paris in such Western landscapes as *The Freighter, Thunder Heads* (cat. no. 42), or *Inyo Range* (cat. no. 54). His late landscapes evoke some of Monet's compositional strategies: the high horizon and precipitous foreground of *Poppies and Lupin* is reminiscent of Monet in the 1880s.

Lungren defined his work as "impressionist," deliberately using a lower case "i" in acknowledgment of his great differences from early French Impressionism. Instead he referred his use of the term to his "trying to render my impressions as recorded by the memory of the subject."[24] He described at length his self-training in memorizing elements of a scene to be painted at leisure, collecting his "impressions" at a site and then organizing and

intensifying them on the canvas back in his studio.[25] His lack of involvement with American Impressionists in New York in the last 15 years of the 19th century and his divergence from the styles and subjects of the California Impressionists once he moved to California suggest that Lungren had no intention of being seen within the discourse around Impressionism and simply chose to adopt those elements that were useful to him. This is consistent with other pragmatic decisions and patterns in his career. Whereas studio-trained artists often develop sensitivities to theoretical points, such as their choice of subject, their use of black pigment, or their depiction of space, Lungren seems to have ignored academic considerations, choosing instead to follow intuition and emotions. If anything, his decisions seem conservative, in the general sense of avoiding controversy and complications, keeping focused on what he cared about.

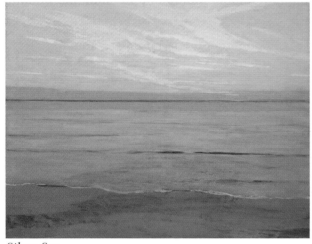

Silent Sea
Cat. no. 63

Henrietta died in 1917, sending the artist into deep despair and curtailing many of his social activities. It is possible that his output dropped considerably. Berger records how Lungren's wife had created his society connections, organizing teas for him to exhibit recent works each year. After her death the artist was drawn into the society of the city. He was particularly involved in the creation of the Santa Barbara School of the Arts (1920 –1938), serving as its first president and remaining active as a teacher and an advocate until his death. The only paintings we know he originated in the 1920s were backgrounds for two dioramas for the Santa Barbara Museum of Natural History. In 1925 he painted the Colorado desert for a display of desert birds, no longer extant; in 1929 he repainted *Death Valley from Dante's View* to create the environment for a mountain sheep display. That diorama stands alongside *In the Abyss* as one of the artist's surviving masterworks. The high value he placed on that early painting is confirmed by a series of late portrait photographs made of the artist (see cat. no. 74). Sitting in a wicker armchair, standing quietly, or pretending to paint a few finishing touches, Lungren posed in front of his largest completed easel painting.[26]

We have few details about the very end of Lungren's life. Brett and Buella Moore, who moved to Santa Barbara in 1930, lived with him in his last years and helped manage his career, caring both for the paintings and their

24

maker. Brett Moore was involved in repairs to the dioramas and helped Lungren continue to paint. One might speculate that *Lungren Home: Mission Canyon* (cat. no. 65) was painted at the very end of the artist's life. Whereas most of his mature work records more distant (and strenuous) sites, this somewhat tremulous and tentative oil sketch represents the mountains that border Santa Barbara. One could imagine the aged artist persisting in painting although his horizons had been limited by infirmity.

As this narrative suggests, Lungren's early work follows a clear trajectory. Most of his paintings and drawings can be dated to specific illustration jobs or trips, while his exhibitions history helps us anchor other pieces. Accordingly this retrospective falls into two distinct sections, a chronological survey of his early work and a representative selection of his later pro-duction. In fact, there are two options for sketching the shape of Lungren's late work. Either he produced very little or he realized a group of daring land-scapes that were heavily reworked sever-al times. In this catalogue I experiment with the latter notion, dating as 1920s a group of works I had originally placed earlier. The dense craquelure of these paintings, ostensibly a sign of age, may reveal peculiarities in how they were made. Paradoxically, it is probably his

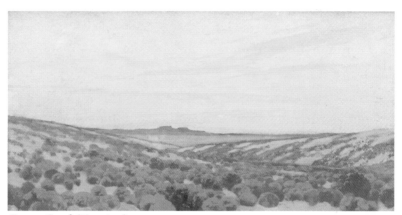

Desert Sand (Evening)
Cat. no. 58

last, more recent paintings that look the most "beat up," or distressed by the passage of time. *Lava in the Desert* (cat. no. 54), *The Carpet of the Desert (Evening)* (cat. no. 57), *Desert Sand (Evening)*, and *Silent Sea* (cat. no. 63) go further than other desert scenes in realizing the extraordinary coloration of transitional times of day, from early dawn to the deep blues after nightfall. It is possible that as he approached the end of his life Lungren grew nearly obsessed with such nuance and affect. He may have returned many times to the same segment of paint, trying repeatedly to achieve some specific quality of light or hue. Berger testifies that Lungren often reworked canvases in the studio, describing his painstaking search for the exact color or effect he had observed.[27] He probably experimented with the available media to create special effects. The conservation undertaken in the three years preceding this exhibition confirmed that many of the areas of dense craquelure had indeed been

25

repainted. The extensive "interlayer cleavage," or separation between layers of paint, might be caused by applying new passages many years after the canvas was completed (it might also suggest a shift in the chemical composition of the paints). In a few cases a significant layer of paint had lifted enough for us to see the section below, where the colors or even the motif were different. Sometimes the delicate area responded too quickly to any treatment, suggesting the artist employed some experimental materials—perhaps draining off oil from paints or adding sections in casein or tempera. We hope that future work can include X-rays and pigment analyses to confirm some of these hypotheses.

Thus, even what might seem to be a technical fault ends up as meaningful evidence of Lungren's intentions. Both his reuse of similar compositions and his return to rework certain passages suggest a deep involvement, even an obsession with this subject. His late theme might be considered the afterglow, the liminal shift from darkness to light and back again, the exquisite nuances he learned to perceive in the landscape he loved. In the transitional moments of sunrise and sunset Lungren discovered a pyrotechnic display more spectacular than the fireworks he painted in London at the turn of the century. Such pictures of open space, whether Death Valley, the Mojave Desert, or the region around the Grand Canyon, represent a dynamic and passionate linkage between art and the environment, one that continues to inform painting in California to the present day.

Elizabeth A. Brown

1 The name of the local college changed frequently on its path to becoming UCSB. It was the Santa Barbara State Teacher's College from 1921 to 1935. Previously it had been a Normal School, as was typical of teachers colleges in the U.S.A.

2 Last Will and Testament of Fernand Lungren, signed November 2, 1932, Ninth item, p. 3, Collection files, University Art Museum (hereafter UAM archives).

3 In 1915 the Normal School provided a venue for an exhibition of Santa Barbara artists, John A. Berger, *Fernand Lungren*. Santa Barbara: The Schauer Press, 1936, p. 202 (hereafter Berger).

4 Letter from Francis Sedgwick to UCSB Chancellor Samuel B. Gould, August 29, 1960, UAM archives.

5 According to the Last Will and Testament, all of Lungren's papers were given to Stewart Edward White. Their whereabouts is not known.

6 Berger, p. 164, "…it was the subtle mystery of the desert which he wanted to penetrate, then to interpret by his art. To conquer that obsession became his engrossing, gripping purpose."

7 Edward Strahan and F. Hopkinson Smith, *A Book of the Tile Club*. Boston and New York: Houghton Mifflin and Company, 1886.

8 *Century Magazine*, Vol. 5, January 1884, pp. 356–71.

9 Other examples include *The Seine at Twilight*, Hirschl & Adler Galleries.

10 For a vivid account of the "Great Surveys" and their impact on photography see May Castleberry *et al.*, *Perpetual Mirage: Photographic Narratives of the Desert West*. Exh. cat., Whitney Museum of American Art, 1996. For detailed accounts of the four main expeditions see Richard A. Bartlett, *Great Surveys of the American West*. Norman: University of Oklahoma Press, 1982.

11 Jane Dini has discovered that a copy of this publication was gifted by Lungren to the Santa Barbara Museum of Natural History Library, although its whereabouts is not known.

12 C. A. Higgins, *Grand Cañon of the Colorado River*. Chicago: Passenger Department Santa Fe Route, 1893.

13 Higgins, p. 21.

14 *Nocturne in Black and Gold* (1874, Detroit Institute of Art) was the subject of a libel suit. John Ruskin castigated the work for "flinging a pot of paint in the public's face." Although Whistler won the legal battle, he was awarded only a farthing in damages, which ruined him financially.

15 Recounted in a manuscript or journal by the artist, published posthumously as *Fernand Lungren: Some Notes on His Life*. Santa Barbara: School of the Arts, 1933, p. 25.

16 Ibid., pp. 26-27: "The invitation was one in which practically all expenses were to be paid by Mr. Welcome (sic). Much as we wished to go, we could not accept on those terms, and made a more satisfactory arrangement."

17 Ibid., p. 36.

18 "[W]hen I came face to face with a nature I could sit down before and become friends with, the method at first was of another order. Then, as you come to know a person, certain traits, characteristics and mannerisms show as you know them better, so it seemed to me the same applied to nature." Ibid., p. 44.

19 Berger, p. 140.

20 *Harper's Weekly*, Vol. 40, February 8, 1896, pp. 126–28. For a discussion of the two versions of *Thirst*, see Dini below, pp. 35–37.

21 William Allen White, "On Bright Angel Trail," *McClure's Magazine*, Vol. 25, September 1905, pp. 502–15. Cf. Berger, pp. 134ff. The typescript, with corrections in Lungren's hand, is in the UAM archives; White's cover letter refers to his writing as transcribing Lungren's voice.

22 Berger, pp. 168 and 292–93.

23 Kirk Munroe, *The Painted Desert: A Story of Northern Arizona*. New York: Harper & Brothers, 1897. Cf. plates facing pp. 2, 132, and 272.

24 *Some Notes*, p. 43.

25 Berger, p. 304.

26 None of the photographs is signed, but their compositions and tonal range suggest the work of Carolyn and Edwin Gledhill, prominent figures in the Santa Barbara art world of the 1920s, or their followers.

27 Berger, pp. 170 and 174–75.

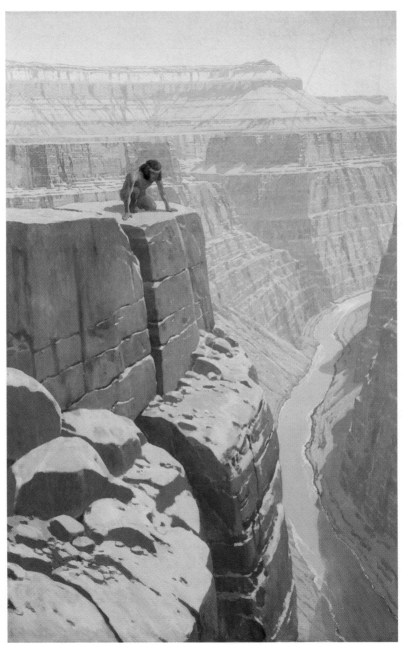

In the Abyss: Grand Canyon
Cat. no. 7

Drawn to the Light:
The Desertscapes of Fernand Harvey Lungren

*I*n 1897 *Fernand Lungren exhibited In the Abyss: Grand Canyon,* an image of a Navajo crouched on hands and knees peering over the edge of a sheer cliff in the Canyon (cat. no. 7). This painting marked the first phase of the artist's visits to the desert, a passion that would consume him for the rest of his life. Lungren later recounted these early trips West in which he served as an artist for the Santa Fe Railroad, saying that he had turned his back on "the ease of the East to return to the land of mirage and beautiful desolation."[1] By "ease" Lungren refers to the world of high bourgeois life that had filled his early illustrations. He dreamed of replacing such materialistic subjects with the refined purity of the desert.

Upon his death in 1932, Lungren had fulfilled his desire to be known as the foremost desert painter of the Southwest. His obituary in *The Art Digest* reported, "His favorite theme was the desert, which he loved so sensitively. He was considered the first artist to paint accurately as well as with consistent artistry, the clear translucent atmosphere and rich colors of the desert."[2]

Lungren's early artistic career was spent as a magazine illustrator in New York City during the 1880s and 1890s.[3] His wide-ranging assignments varied from sketching the life of New York's poorest city dwellers for H.C. Bunner's "Shantytown" in *Scribner's* to capturing the leisurely pursuits of the same city's upper classes for Frances Hodgson Burnett's "Little Saint Elisabeth" in *St. Nicholas Magazine*.[4] Lungren's vision was shaped by the consumer culture that was advertised and endorsed by these popular magazines. Little St. Elisabeth bears her title because of her saintly mission, buying Christmas presents for the city's poorest children, but in Lungren's illustration, *On Errands for Santa Claus*, she is a also a fashion-plate in velvet coat and fur muff striding along the avenue with her maid in tow. In Lungren's illustration for "Shantytown," a junkman's rambling hodge-podge domicile is packed with an accumulation of, in the words of the article, "boxes, barrels, baskets, stove-pipes, bottles, cartwheels, odds and ends of

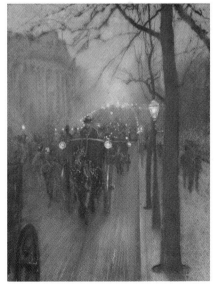

Picadilly Slope
Cat. no. 18

29

furniture." In both cases consumer goods, whether found or bought, are signs of the cultural achievements and aspirations of their possessors.

On travels to the Southwest in the 1890s, the way in which Lungren recorded, for example, the possessions of the Hopi, their baskets and pottery, was directly informed by the excessive consumption that his previous art depicted of his own culture. Ironically, his late desert landscapes, painted in the first two decades of the 20th century, although devoid of human activity, served to further the interests of that consumerist culture: what at first glance appear to be the romantic meditations of a crusty old desert painter, eschewing worldly goods and embracing the life of a maverick and loner, are in fact images inextricably bound up with the development of the West and the increased commercialization and marketing of the Western experience.

In the summer of 1882, Lungren sailed to Paris with several members of the Tile Club, a group of New York artists including William Merritt Chase who embraced the Aesthetic Movement and displayed their experimental designs on ceramic tiles.[5] Although he was not an official "Tiler," Lungren was included in their

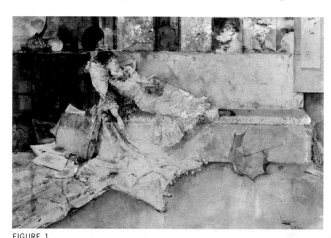

FIGURE 1

Lady Reclining on a Sofa, c. 1884
watercolor, 14 x 20 3/4 in.
Courtesy Hirschl & Adler Galleries, New York

Parisian painting and sightseeing trips. The 1882 Paris Salon included American expatriate James McNeil Whistler's *Arrangement in Black No. 5: Lady Meux* (1881), a full-length portrait of British socialite Valerie Meux. The image, with the striking contrast of black low-cut velvet evening gown and full-length white sable stole together enveloped in the darkness behind, received mixed reviews. But not from the Americans abroad; from this moment on, Whistler shaped Lungren's aesthetic viewpoint.

While in Paris, Lungren studied briefly at the Académie Julian (years later he regretted his decision to leave early). He complained of crowded classrooms and meager instruction where there was virtually no attention to his efforts. Still, the city afforded him exposure to museums, fellow artists, and non-Western traditions. His fascination with Japanese prints and experimentation with avant-garde trends can be seen in his watercolor, *Lady Reclining on a Sofa* (c. 1884; fig. 1)

a variation of Whistler's *Symphony in White, No. 3* (1865–1867). Lungren's Japanese-inspired Parisian interior, however, lacks the simplicity of Whistler's exercise in white-on-white. Whereas Whistler suggested his *japonisme* with a single paper fan, Lungren's room is cluttered with fans and prints lining the wall and scattered about the floor. In this cabinet of imported curiosities the woman is subordinate to the decor. Lungren's facility for reporting every eye-catching detail undermines the composition's strength. Without a central focus, the image lacks substance and has more in common with the technique of his illustrations than with Whistler's technical approach to the painted surface. It was not until Lungren embraced his desert themes that he truly understood and employed Whistler's revolutionary experiments with form and color.

Lungren would have also seen at the Salon of 1882 Édouard Manet's *A Bar at the Folies-Bergère* (1881–1882), an image of a barmaid at the famous Paris nightclub. Perhaps inspired by these popular café subjects of the French Impressionists, Lungren painted *The Café* (The Art Institute of Chicago, fig. 2). Similar to *Lady Reclining on a Sofa*, *The Café* underscores Lungren's awareness of the burgeoning market economy in Paris more than the compositional innovations of the avant-garde. A fashionable woman sits alone at a marble-top table, holding a glass of wine and leaning forward as if in anticipation. Whereas her pose suggests Edgar Degas' *L'Absinthe* (1878), she shares nothing of the lonely despair of Degas' young working class woman, a type also depicted in Manet's cafe scene, *The Plum* (1878). Lungren's image has none of the pathos of its French counterparts. His woman is in fact gazing across the street at a series of storefronts upon which one reads the letters "au Prin."[6] This suggests the department store Printemps, one of the *grands magasins* that were built along the new boulevards designed by Haussmann. This fashionable woman, gazing longingly at her next purchase, is not an alienated drunkard, but a responsible and well-appointed consumer.[7]

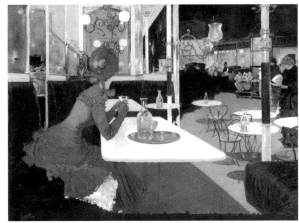

FIGURE 2
The Café, 1882–84
oil on canvas, 31 3/8 x 41 1/4 in.
The Art Institute of Chicago
Charles H. and Mary F.S. Worcester Collection, 1947.85

In the Abyss is also an image of an isolated figure whose gaze is central to the meaning of the picture. Instead of a department store facade, our gaze, aided by our Navajo guide, is directed down the sheer walls of the Canyon. While the Native American and the Parisian are each in

keeping with their surroundings, the woman appears detached, whereas the man seems more integrated with his environment. Not until Lungren observed the close relationship that the Southwest Indians had with their land did his work take on a new intimacy and intensity. The Navajo's position on the cliff, his intense stare, and the immensity of the landscape which stretches out to a seemingly endless horizon are signals that Lungren was not only painting new themes but also striving for a new dimension to his work, one of introspection and mystery. In this way, *In the Abyss* is an inversion of *The Café*; the exterior superficial world of fashion is reversed to reveal the interior world of self-discovery. A cityscape that is emblematic of consumer culture with a figure transfixed on its seductions is replaced by a land that is uncharted and vast, more suited to contemplation, an image metaphoric at once of geologic and psychological discovery.

Initially, Lungren's Western adventures were sponsored by the Santa Fe Railroad to aid in their promotional efforts to increase tourism. On his first trip, he produced 38 paintings and lithographs. Lungren's most ambitious work from this period was a depiction of a Hopi Snake Dance, *The Snake Dance, Tusayan* (begun 1895). Exhibited unfinished at the American Art Galleries in 1899, the mural-size canvas (7 x 12 feet) was believed still to be in the artist's studio upon his death.

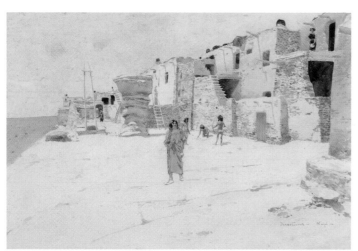

Dance Court, Walpi
Cat. no. 9

Lungren witnessed the Snake Dance in August 1893 at the Hopi First Mesa Village of Walpi in northeastern Arizona. The ritual, performed by priests from the Antelope and Snake fraternities, concludes 16 days of ceremonies to ensure the bringing of rain. Lungren's visit coincided with the field work of the famous anthropologist, Jesse Walter Fewkes (1850–1930), who studied the Snake ceremonies between the years 1891 and 1897. Fewkes documented Lungren's participation: "The ceremony in 1893 began on August 6, and was studied throughout by Mr. A.M. Stephen and J. Walter Fewkes. Messrs. Julian Scott, F. H. Lungren, and W.K. Fales were admitted to the secret ceremonials of the Moñ'-kiva, and were at our request initiated into the Antelope Fraternity."[8]

Due to its fragile condition, *The Snake Dance, Tusayan* cannot be exhibited, but a version of the painting was included among Lungren's illustrations for Hamlin Garland's 1896 article, "Among the Moki Indians," which appeared in *Harper's Weekly* (cat. no. 77). Although there are certain minor details modified from the original, the figure groupings and background elements are virtually identical.

Lungren's watercolor study, *Dance Court, Walpi* (1893), depicts the distinctive features of the Walpi Pueblo that he incorporated in *The Snake Dance, Tusayan*. Most prominent are the tornado-shaped Snake Rock and the ladder to the entrance to the Middle kiva (Nashabki), which is associated with the Snake Society. Here Lungren is placing and getting a feel for the features of the pueblo and understanding the play of light and shadow on the adobe and stone surfaces of the terraced houses.

Lungren took great care in detailing the costume and ritual activities of the Hopi. In *The Crier* (c. 1896; cat. no. 10) he shows the Walpi Pueblo at sundown as the villagers break from their tasks to listen to a priest, seen

high on top of a roof in the background, announcing the upcoming ceremonies. The scene relates to Lungren's illustration, "Hoñi, The Talking Chief, Announcing the Snake-Dance Sixteen Days Before its Occurrence," for Garland's written account in *Harper's*. Lungren's magazine illustration is a close-up of the priest, but for *The Crier*, he pulls the view back to reveal the entire interior courtyard, creating a kind of anthropological drama that documents the Hopi dress, hair style, and custom.[9]

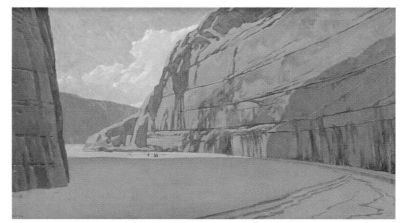

Entrance to Canyon del Muerto from Canyon de Chelly
Cat. no. 11

Lungren treated his new Hopi friendships and associations with reverence and respect. Yet his images still participated in an arena that served to make the Native American strange and exotic. For instance, in the *Harper's* article that Lungren illustrated, Garland describes his first meeting with the women of the Ho-ni Pueblo. "Little Quang, so Japanese you could not believe her to be Indian; her hair combed into great whorls at the side, her

eyes black as melon seeds, her hands slender, her naked feet small and brown." Lungren had lofty ambitions for his Southwest subject matter and he thus created pictures that romanticized the Hopi. The format of *The Snake Dance, Tusayan* was modeled after 19th century Salon paintings whose size and grand compositions were intended to elevate the subject matter. In his description of the Snake Dance, Garland reveals Lungren's intentions for depicting the ceremony: "Upon every cornice, every roof, every adobe balcony, the Mokis themselves were gathered, attired in the most brilliant and the quaintest costumes. The building rising against the deep blue cloudless sky, covered with these barbaric colors, made a picture worthy [of] the brush of the finest artist. As a painter said, 'It was a Salon picture'."[10] One presumes the painter to whom he was referring was Lungren, who believed he had found subject matter that would bring him great acclaim.

This shift in the mood and content of Lungren's work from his New York and Parisian subjects to his Southwest images reflects the artist's identification with Native American culture and a feeling that it was more "authentic" than his own. Lungren's biographer, John A. Berger, recounted the artist's impressions of the Hopis upon his adoption into the tribe and his initiation into the clan of the Honani as an honorary priest: "Again that inexplicable feeling of familiarity swept over him. Easily and naturally the natives seemed to accept him as one of their own. Soon he was on friendly terms with most of the priests of their two fraternities."[11]

At the same time Lungren believed he was discovering and depicting a more genuine culture, he was producing images that played a part in the mythologizing of the West. He recalled of his childhood fascination with Native American culture, "The West too, called me early, for a little later when I was supposed to be imbibing that chaos of odds and ends known as 'lessons' I was delighting my companions if not my teacher, depicting the noble red man in the usual sanguinary spirited conditions disclosed through the medium of Mr. Beadle's dime novels."[12] As he grew older, Lungren replaced these popular children's stories with more adult fare. For instance, the title *In the Abyss* recalls the dramatic descriptions of the plateau deserts by the naturalist Charles Lummis whose books Lungren had read and admired long before he journeyed west.[13] Lummis' *A Tramp Across the Continent* (1892) set the stage for how Lungren would greet the Grand Canyon and title his works. Lummis wrote, "It is incomparably the greatest abyss on earth—greatest in length, greatest in depth, greatest in capacity, and infinitely the most sublime."[14]

Whereas *In the Abyss* was informed by literary embellishment, Lungren was also responding to the on-going scientific documentation of this land. *In the Abyss* recalls several of the photographs taken by John K. Hillers

for John Wesley Powell's survey of the tributaries of the Colorado River (1871–1878).[15] One photograph in particular, which appeared in Clarence Dutton's *Tertiary History of the Grand Cañon District with Atlas* (1882), is the possible visual prototype. *Inner Gorge of Toroweap—Looking East* by Hillers shares striking similarities to Lungren's *In the Abyss*.[16] In the photograph, one of the members of the scientific exploration team sits in almost the exact location where Lungren would place his Navajo. In the painting, we assume Lungren's figure to be in a dangerous location in a remote part of the Canyon. This increases the awe and drama of the scene. But as Hillers' photograph makes clear, this area of the Canyon was not as inaccessible as Lungren would like us to believe. By Lungren's time, the ledge upon which the surveyor and Navajo rest was relatively easy to access and would soon become a popular tourist vantage point from which to view the Canyon. Still, this combination of scientific discovery coupled with romantic splendor was to become Lungren's recipe in his late desert paintings.

By the time Lungren painted his own version of the Grand Canyon there was already plenty of romantic painting and poetic lyricism informing East Coast audiences. Most notably, Thomas Moran's operatic *The Chasm of the Colorado* (1873) figured prominently in the American imagination and helped lead to the ultimate preservation of this majestic wilderness.[17] Over the course of 40 years, Moran painted numerous images of the Canyon and in each he used his artistic license to rearrange landscape features in order to increase the awe and splendor of the scene. Moran's canyon scenes elevated the landscape to the heavenly realm and by extension the viewers to divine providence over the land. This was similar to the kind of picture making employed by Frederic Church, whose *Niagara* (1857) became a symbol of United States strength, or the epic grandeur depicted by Albert Bierstadt in many of his paintings of Yosemite Valley, serving as visual apotheoses of manifest destiny. Such works proclaimed our spiritual inheritance of these native lands. Lungren turned to nature not to make sweeping claims of national identity and promote westward expansion (although his work played a role in such jingoistic exploits), but to compose more personal messages. Nonetheless, the intimate stories that he portrayed served to continue to mythologize the West, albeit not as images that stressed national unity and communal pursuits, but as images that celebrated individuality and self-reliance.

Lungren's desert scenes were inextricably bound up with his personal life story and desires. At around the same time he painted *In the Abyss*, Lungren painted an image of himself alone in the Mojave Desert entitled *Thirst— The Beginning of the End* (1896). The picture was his visual account of the perils that can befall a desert painter in his solitary pursuits. According to Berger, Lungren, on one of his early trips into the desert, was stranded with no water and came close to death. Lungren gave a written account in a catalogue entry that accompanied the

watercolor's exhibition at the American Art Galleries in 1899: "Prospectors or over-confident travelers become confused, lost, and, with water exhausted, wander in circles until their horses die beneath them, and they go mad from thirst and so perish miserably under the brassy sky."[18] This painting of Lungren's dramatic episode was widely exhibited in New England in the mid- to late nineties. In 1896, *Thirst* was reproduced in *Harper's Weekly* accompanied by a review written by Owen Wister, whose Western fictions earned him the distinction of being the most widely read turn-of-the-century novelist. In the black-and-white magazine reproduction, a lone frontiersman has collapsed onto his knees with his horse fallen dead by his side. Unlike *In the Abyss*, where a Native American exhibits confidence and control over the land he inhabits, the Anglo-Saxon male on a desert plateau has been caught in a perilous situation. At the same time that Lungren's image emphasizes a new spirit of individualism, it also warns of the grave consequences to which such a life might lead. This sentiment was reinforced by Wister, who wrote in his review, "Of man's calamity I have only heard, but enough to know that

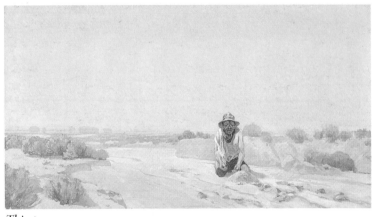

Thirst
Cat. no. 5

Mr. Lungren's picture is too true for—well, for one's sitting-room."[19] Perhaps the supposed verisimilitude of the scene was too coarse for the genteel households of East Coast audiences, but not for Wister's. *Thirst—The Beginning of the End* was one of 10 Lungren paintings that he collected. So invested was Wister in dramatizing the rugged experiences of the West that he encouraged Lungren to embellish the titles of his work. For instance, in 1911 he wrote to Lungren about changing the subtitle of *Thirst*, arguing, "The Beginning of the End is not quite good enough a title for that picture.

You must screw it up a tone or two. I've been able to hit on nothing that will exactly do—but feel about in this direction: 'The Fang of the Desert'—'The Desert's Claw'—'When the Desert Strikes'— it's in that line you'll get at the precise core of the thing, it seems to me."[20] According to the inventory, Wister finally "screwed" the title up to *The Skull of the Desert*, emphasizing the artist's near-death experience.[21] Lungren executed an oil painting with the same title, *Thirst* (cat. no. 5) for his personal collection.

36

Lungren's theme recalls Winslow Homer's epic seascapes painted during the same time. Man's struggle with nature was portrayed in such paintings as Homer's *The Fog Warning* (1885; The Museum of Fine Arts, Boston), a fisherman's race to return to the mother ship as a storm settles over the sea. Lungren's and Homer's genre paintings are at once closely descriptive and dramatic. New England fisherman and Western cow-puncher were both iconic types in America, regional personifications of fortitude and resilience.

Performing the role of the Western adventurer also had a place in the political arena of the time. Theodore Roosevelt embodied the rugged individualism that Wister and Lungren so admired and sought to portray in their literary and pictorial Western adventures. In 1902 Wister dedicated his most famous novel, *The Virginian*, to his Harvard classmate. That same year, with encouragement from Wister that it would be received favorably, Lungren sent *The Dim Trail—Cowboy Trailing Stock* (c. 1898) to the White House. Upon receipt of the painting Roosevelt wrote with thanks, "It makes me thoroughly homesick for the great plains to see it, and Mrs. Roosevelt is as delighted with it as I am."[22]

Earls Court: London
Cat. no. 16

Lungren's talents at Western genre were further enhanced by his increased interest in dramatizing his backdrops. By the 1890s, Lungren's descriptive talent as a landscape painter was in full force. Without the aid of human drama, he painted *Rivers of Stone* (cat. no. 12), an image of black lava along the sandy desert floor. Without the artifice of wild facial expressions or desperate gesticulations as in *Thirst*, Lungren creates a zoomorphic form. The lava appears like the tentacles of a giant landlocked octopus, sweeping the desert with fluidity and grace. Lungren solidifies the composition into a unification of simple parts: sky, sand, and volcanic rock.

Amid such artistic and personal success, Lungren embarked on a belated honeymoon to London with his new wife, Henrietta. Lungren was confident that the English would be impressed with his vision of the Southwest. It proved to be a mistake, for he miscalculated their interest in cowboys and Indians and agonized over

Londoners' disbelief at his depiction of the vivid colors of the desert. Nonetheless, he was lauded for his images of London cityscapes in pastels such as *Earls Court* (cat. no. 16) and paintings such as *The Arm of the Law*, (cat. no. 13). In 1902, William Macbeth, whose gallery on Fifth Avenue in New York was the first to represent exclusively the work of American artists, exhibited a group of Lungren's London pastels. Introducing the catalogue, Macbeth proclaimed, "In the little group of pictures here catalogued misty, moist, noisy, busy, overpoweringly great, London is before us, as seen under the oft-needed artificial light. The tangle and confusion of traffic, the fogs, and the blackness relieved by glowing lights from gas and electric lamps, or reflected from river or wet streets, all these aspects of the great metropolis are put before us in a wonderfully vivid and enchanting manner."[23]

As able as he was to create such dank images, Lungren longed for the sun and the heat of the Southwest. Charles Lummis was an eager supporter of his return. Over the previous decade, Lummis and Lungren had become confidants. They shared a mutual respect and admiration fueled by their love for the desert. Through their frequent correspondence during Lungren's London sojourn, Lummis expounded on the merits of the California lifestyle and assured the recent newlyweds that rental costs were not as high as they feared. Lungren, in turn, tried to cure his homesickness with Western flights of fancy. In a letter to Lummis written in 1900, Lungren identifies so closely with the Arizona landscape that he imagines himself to be the cowboy he depicts:

> I have just painted a "round up" which I think you would enjoy. The whole thing is flooded with that intense white sunlight so characteristic of the plateau and the alkali drifts away from the herd against that Arizona sky in both angles. The thing is very real to me and it makes me homesick. I want to be the "puncher" who is coming head on heel to split after a big bay steer jumping out of the canvas on the sage bushes. Whoopla! I feel the pony jumping under me now![24]

Lungren also confided in Lummis about his disenchantment with London audiences. His Western subjects were not well received: "Lummis the biggest mistake I ever made was bringing the pictures out here….Well, if the Lord will let me I will go west and paint more and better ones for people who do know and the more I think of it the more I want to do it for the pure love of it."[25]

Seeking more arid climes, the Lungrens accepted an invitation in 1900 to visit Egypt. On this excursion from London, Lungren rekindled his passion for the desert. He and his wife spent seven months in Egypt and the Sudan. The following entry from his recently rediscovered Egyptian diary illustrates how he was honing his skills as an observer of the desert; for the artist the desert was a rich palette of color more than an emptiness: "The

desert — bleak and bald, beautiful in color against the changing sky, while from the river's edge back to the palm trees was a stretch of brilliant green new grass. The contrast was startling in the level light."[26]

Lungren's painting *Along the Shore: Evening* (cat. no. 21), an image of feluccas sailing up the Nile at sunset, exhibits a directness of light and richness of color that the artist could not capture in his cityscapes. The moon rises over the river's embankment and casts a white beam of light on the water's surface. In the distance, the silhouettes of date palms mark the desert's edge. Lungren's attention to the effects of light on the surface of land and water is even more evident in his oil sketch, *The Pyramids* (cat. no. 22) where the tombs of Chephren, Cheops, and Mycerinus are composed with vivid purples and pinks. This reacquaintance with the desert in Africa convinced Lungren that he had to return to his own.

Pyramids
Cat. no. 22

In the fall of 1903, after a brief sojourn near New York City, Lungren and his wife returned "home." Lummis had indeed been an important catalyst, and true to his word, helped the couple to relocate to a cottage next door to his own Western-style abode in Los Angeles.

For the next two years Los Angeles became their western residence. Oddly, Lungren set out as he had in London to paint the city at night, illuminated by light in the rain, as in *Fifth Street at Hill: Looking East, Evening* (cat. no. 27). Ironically, for a man who later became known for excelling in his depictions of dryness, his early acclaim was based on mastering the illusion of wetness. In the early 1880s, while still in Paris, Lungren had painted *Paris Street Scene* (c. 1882; Terra Foundation for the Arts, Chicago), an image of a rainy day along the Seine embankment with groups of Parisians scurrying across a bridge beneath clusters of black umbrellas. He used this theme in different urban locales, Paris, London, New York, and finally Los Angeles. His shift to desiccated Western landscapes marked the further evolution of a style intricately dependent on tonal and atmospheric effects. In fact, Lungren identified himself as an Impressionist: "I call myself an 'impressionist' because of my way of looking at things, for there can be no resemblance in my handling with the early technique of the first impressionists."[27] With such a broad generalization, Lungren could label his technique impressionistic while still utilizing a number of artistic methods.

Lungren feared that his sales would be few in California, but his worries were unfounded. Around 1905, he had a show and sale of paintings at the newly opened Steckel Galleries in Los Angeles.[28] The exhibition included 23 oils, pastels, and watercolors of Egyptian, London, and Western scenes, of which Lungren sold approximately 6. *Through the Rocio—Afterglow*, a scene of a Navajo family traveling through a Southwestern landscape, was purchased by The California Club, an exclusive gentlemen's club in Los Angeles.

When he and his wife moved to Santa Barbara in 1908, the Lungrens were received into the top social circles. Lungren's paintings were collected by the town's old guard as well as its newer arrivals. After only three years in Santa Barbara he was able to write that, "People like Owen Wister, Stewart Edward White, Richard Crane, George Bence Douglas, Charles P. Bowditch, Miss Charlotte Bowditch, William Dreer, Staats Forbes, Mrs. Charles B. Raymond and many others" seemed to care for his work.[29] Although exhibition and sales records suggest that Lungren's clientele received all his subjects favorably, from sunbaked Arizona to foggy London, he decided to make a pivotal change in his oeuvre. He would abandon all representation of human activity and concentrate solely on painting the landscape. All the emotionalism of narrative would be infused into the drama of the land. According to Berger, "Up to the present he had painted landscapes primarily as a background for Indian life. This new section, with its mountains, canyons, lakes, streams, deserts, lava, trees and rabbit-brush, was so complete that he never missed the human or pictorial element. In a country offering infinite variety, the landscape itself became the artist's obsession."[30]

The Arm of the Law/Hyde Park Corner, London
Cat. no. 13

From this point on, the desert became Lungren's métier. In paintings such as *Inyo Range* (cat. no. 53), Lungren used the same dramatic light effects that he had employed in his scenes of the Grand Canyon. In the foreground, blue sage brush carpet the desert floor. Recumbent hills crisscross into the middle distance, leading the eye back to orange and pink mountains rising over the plane. Such an improbable combination of colors was exactly what Lungren was looking for in this landscape. In an undated treatise, evidently written after

much experience, he recounted his intense investigations in the desert. Clearly, Lungren saw the desert painter as a special breed, as separate and apart from other landscape artists.

> One who has once come under the spell of the desert and has learned to love its wonderful elusive beauty, its wide stretches of apparent nothingness yet replete with charm and subtlety, its color and majesty of form, there remains no choice but to return again and again [even though] these be vivid memories of hardships, and grave danger from thirst or illness or accident. And when a painter comes to know and care for this desert land and life, there are few things worth while to him in comparison.[31]

Lungren's work promoted the glory of the desert and his writing explained the necessity for its preservation. Yet he did not perceive the political ramifications of some of the most notorious environmental decisions of his era. Most notable was his association with Joseph B. Lippincott, who played a role in redirecting (as a member of the Bureau of Reclamation) water from the agricultural Owens Valley, hundreds of miles to the north, to Los Angeles. According to Berger, "The mammoth undertaking interested Lungren intensely, and he promised to accompany Lippincott on an exploration trip into Owen's Valley."[32] Although Lungren expressed reservations over the proposed plan as early as 1905, neither he nor Lippincott, who reputedly owned the artist's work, had the foresight to understand the complexity of the water politics of Southern California and its connection to the painter's beloved arid planes.[33] As a result, several of Lungren's scenes are now documents of a vanished land.

It was the Southwest deserts and particularly the California deserts that Lungren would claim for his own. He wanted to master every locale of this arid country. He wrote of his extensive travels:

> Take it all in all there is no more interesting and wonderful country to be found than this desert country of the South West and West. In a trip just completed, starting from central Arizona through the Painted desert, Ho-pi pueblos, the Canon de Chelly, the Chin Lee Valley, Along the Colorado, in Death Valley and adjacent Country, every variety of country and weather ever encountered, and the Conviction is Emphatic that there is no Country like it.[34]

Lungren was enchanted with the entire Southwest, but the desert he would return to paint again and again was Death Valley. For over 20 years, the vista from Dante's View, a vantage point high above the desert floor, would become his signature view. In Lungren's striking panorama *Death Valley: Dante's View* (cat. no. 38), he juxtaposed the impressive peaks with the low desert floor streaked with salt rivers. Here was the serene beauty of the desert coupled with the drama of geological creation. In 1911, from Dante's View, the artist wrote to his "Beatrice": "I think of you constantly, my sweet wife, and at night I look at Sirius, the bright star near the constellation of Orion, and tell myself that you too are looking at it."[35] From the romantic to the awesome, Death Valley inspired some of Lungren's most dramatic compositions.

41

The drama of Death Valley was captured in *A Cloudburst* (cat. no. 51), an image of a thunderhead rising over the Eastern slope of the Panamint Mountains. Like a diaphanous veil, virga rain falls from the cumulus onto Telescope Peak. The giant cloud billows out with power and force. Lungren captured another dangerous weather condition in Death Valley in *Sand Specters: Death Valley* (cat. no. 44), an image of a violent sand storm along the desert floor. The wind whips through the creosote trees creating a sense of motion that was seldom seen in Lungren's desert scenes.

Death Valley is the setting for Lungren's background for a diorama including bighorn sheep at the Santa Barbara Museum of Natural History. Begun in May 1928, the diorama (22 by 17 feet) depicts a bighorn family, male, female, and juvenile, climbing up to Dante's Point, a magisterial view of the Valley stretching back behind them (fig. 3). After Lungren had been working on the diorama for over 16 months an observer from the Museum recounted, "Mr. Lungren has been gilding the lily. He was the only person not satisfied with the Death Valley background for the Mountain Sheep group. He has been sitting for hours on a platform built out precariously from Dante's View, six thousand feet above the valley, changing the values of the Panamint Range, and increasing the debt of gratitude which the Museum already owes him."[36]

After years of travel, Lungren, the experienced desert rat, wrote *Going in to Death Valley*, which served as a road map and tourist manual. He reported to fellow travelers:

> At Furnace Creek after passing the ranch you come to the Inn where every comfort is found. Follow the signs. From there a trip down the valley in the afternoon over the Devil's Golf Course or salt belt to Bennett's wells is well worth taking as the western sun paints the Grapevine and Black range in gorgeous colors. The great view of course is obtained from a point on the crest of the Black range called Dante's view, and very wonderful it is. This view should be seen in the morning to be enjoyed at its best.[37]

The solitude that Lungren felt in the desert is suggested in *Desert Sand (Evening)* (cat. no. 58), a depiction of the Arizona desert in the spring. Three kinds of shrubs dot the landscape; the new yellow blooms of the golden brush, the young green leaves of the ancient creosote tree, and the dusty gray bloom of sage. In the middle distance, the broad arid valleys stretch back to the buttes capped with lava flows. This is the desert, at once ancient and new, regenerating itself. Thin, pale pink clouds accent the evening sky and the light casts a green glow over the land.

In the first two decades of the 20th century, the desert mystique was at the height of popularity in the United States. Willa Cather, Lungren's contemporary, wrote a fictional account of a European's encounter with the Southwest. *In Death Comes for the Archbishop* (1927), set in the mid-19th century, she foretold how the New Mexican desert would penetrate the psyche of a generation of painters: "This mesa plain had an appearance of great antiquity, and of incompleteness; as if, with all the materials for world-making assembled, the Creator had desisted, gone away and left everything on the point of being brought together, on the eve of being arranged into mountain, plain, plateau. The country was still waiting to be made into a landscape."[38]

In 1898, art historian John C. Van Dyke, traveling through the Californian desert on Indian pony, wrote in particular of desert clouds, "They vibrate, they scintillate, they penetrate and tinge everything with their hue. And then, as though heaping splendor upon splendor, what a wonderful background they are woven upon! Great bands of orange, green, and blue that all the melted and fused gems in the world could not match for translucent beauty. Taken as a whole, as a celestial tapestry, as a curtain of flame drawn between night and day, and what land or sky can rival it!"[39] As if in illustration, Lungren's painting, *Pink Cloud* (cat. no. 60), proclaims the vibrant and extraordinary colors to be found in the barren landscape.

FIGURE 3
Diorama of Bighorn Mountain Sheep
(detail)
Santa Barbara Museum of Natural History

Tonal harmonies and Western romance were bound together in Lungren's *Sands of Silence* (cat. no. 45) a depiction of the drifting and barren sand dunes of Navajo country.[40] Titled by Wister, the image is a range of pink hues which owes much to Whistler's color experiments. If most of Lungren's painting titles lacked the luster and romanticism of a Wister tale of the West, the artist's designs for the overall scope of his desert scenes were grand and ambitious. Lungren wrote of his future plans in the third person: "It came to him that no thorough or complete record of the desert had ever been attempted pictorially. A picture or two by this painter of that,—but no record of all the desert phases, its life, its changing light and color seriously undertaken…"[41]

As Lungren set about chronicling the different deserts of the Southwest, he often avoided identifying specific locations. Sometimes, Lungren collectors were not satisfied with his generalized descriptions. When Santa

Barbarans Donald and Charlotte Myrick asked Lungren to sign their painting, *In the Painted Desert* (1912), they coaxed him to divulge the time and locale: morning, approximately 6:00 a.m., the Walker Pass at the southern end of the Sierra.[42] Moreover, although the artist studied botany and natural science and painted the varied plant life of the desert, he rarely identified any of it. Lungren's *Road to the Corral* (cat. no. 30) captures the fall colors in the Owens Valley on the east side of the Sierra. A scene in mid-October shows the artist's knowledge of the area's horticulture. Following a ditch along the side of a dirt road, Freemont cottonwoods have turned a brilliant yellow; their branches lean down to the blooming circular rabbit brush that dots either side of the road. Interspersed between the cottonwoods are the scraggly bushes of the wild rose. The

Fireplace in Lungren's Studio with Santa Clara Pot
Cat. no. 73

road stretches back to meet Lombardy poplars, standing straight and tall, their leaves another blaze of yellow. This fire of color and complementary forms takes place in front of an intense blue sky.

The light and colors of specific times of day are the primary themes of these desert landscapes. In Lungren's nocturnes, *Full Moon in the Mojave Desert* and *Rose Buttes, Moonlight* (cat. nos. 61 and 62), he uses the desert as pretext for poetic meditation. The tonal gradations are refined and subtle, creating a mood of quiet reverie. Elevated to the sublime, the desert becomes a land of spiritual discovery.

Most likely, Lungren finished all his major desert subjects in his studio.[43] In a description of his house he wrote, "I have a large roomy studio, with a gallery opening off it, where visitors can enter on certain days without disturbing me."[44] Lungren's studio in Santa Barbara's Mission Canyon was also a showcase for his collection of Native American artifacts. A photograph taken in the large room that served as both a studio and salon (cat. nos. 71–73) shows an enormous fireplace inset with Hopi tiles of Kachina figures. Placed on the mantel are Hopi and Zuni baskets, over which hang a Navajo bear skin with porcupine quills and an Apache shield. Hanging below the mantel are two Hopi canteens. Upon the hearth rests an Apache drum and other assorted pottery. Many of these objects, costumes, and decorations appeared in his painting of Native Americans, such as the Hopi canteens in the foreground of *The Crier* (cat. no. 10).

Lungren's studio announced the artist's extensive travels and displayed his rare acquisitions, promoting his skills as a painter and interpreter of Southwest culture. In this way, Lungren's studio functioned like many of the grand studios of New York with which he was very familiar. As Sarah Burns has noted, at the end of the 19th century, cosmopolitan studios such as William Merrit Chase's Tenth Street Studio in New York shared a close kinship with the new department stores. She explained, "The formal studio reception, which became a feature of art life in the early 1880s, was a mode of advertising as well, a public-relations event."[45]

In the 1920s, friends would recount with delight Lungren's annual tea party to which the entire Santa Barbara arts community was invited. There, the assembled company would gaze in wonder at Lungren's extensive Western trophies. Each object was associated with a story of adventure. They were not acquired from established galleries or cultivated dealers, but were traded for on the "wild" frontier. Sometimes an object related to a personal remembrance, others were shrouded in mystery, like the man himself. Western novelist and Santa Barbara resident Stewart Edward White remembered, "He was raised to the rank of Antelope Priest. In this capacity he took part in the secret rites and ceremonies including the immunizations for the snake dance. I often urged him to disclose at least the practical parts, so to speak, of what he had learned but he always considered himself bound by his oath of secrecy."[46] Lungren created a mystique about himself and his work. What better way to lead the community to believe that he was the preeminent interpreter of the Southwest?[47]

In 1917, Lungren's wife of 20 years, Henrietta, died. Lungren was bereft and in subsequent years found it a challenge to muster the will and desire to paint. Grief-stricken, he wrote to his old friend. "My Dear Lummis, 'Sunny Jim' is dead, and life is only a gray blur ahead of me."[48] Lummis tried to shore up his friend: "You knocked me all of a heap! It does not seem possible that young and lovely 'Sunny Jim' can be gone. I can remotely guess what it means to you …, God bless you and comfort you, Old Man, and give you strength to go ahead with the only thing in the world that is a safe-guard at such a time—which is to Work like Hell."[49]

During his remaining years Lungren's friends kept him interested in the desert that he cherished, and younger artists sought him out for his technical expertise. In 1920, Lungren helped to found the Santa Barbara School of the Arts, which offered classes in music, dance, theater, and the fine arts.[50] Although he might have been a recluse on occasion, a photograph shows Lungren dressed in a Mexican habit during Santa Barbara's annual summer fiesta celebration, Old Spanish Days (Santa Barbara Museum Historical Museum; fig. 4).

In 1930, the artist Brett Moore and his wife moved into Lungren's house, where they served as caretakers and companions. Moore valued the instruction he received and in turn assisted with Lungren's larger projects. That year Moore made repairs to Lungren's diorama in the Santa Barbara Museum of Natural History under the supervision of his mentor's keen eye.

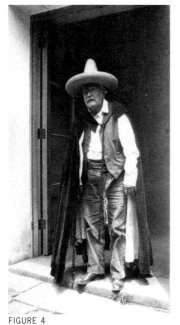

FIGURE 4

Fernand Lungren at Fiesta
Santa Barbara Historical Museum

Although accounts vary about Lungren's productivity in his later years, several letters suggest that he remained interested and enthusiastic about his work and the land that he loved. In 1931, Lungren wrote to Mrs. Hope Henderson:

I have just finished here a book on astronomy....beyond certain information and the science of the great harmony of movement which is in itself a great beauty of motion... there is no work of course as to the physical beauties of that world about us. Thank God I am and have been an apostle of it and have been given my share, such as it is of its wonders, which in some small measure I have been able to interpret to others.[51]

It was his interpretation of the desert, above all else, that Lungren sought to leave as a legacy to the City of Santa Barbara. He wrote in his Last Will and Testament seven days before his death

As my artistic efforts seem to have given a large number of people considerable interest and pleasure, the expression of which by them has been a great source of happiness to me, it has seemed well, through the instrumentality of this trust, to preserve in one group those pictures remaining in my studio and gallery to be held permanently for the use of the people of the City of Santa Barbara and its vicinity, in memory of my wife and myself, in appreciation of the happiness we found in this community.[52]

Lungren's reluctance to sell his late paintings of the desert and his skepticism about the intentions of art dealers impeded commercial attention to his work following his death. But a reevaluation of Lungren's illustrations, Southwestern subjects, and desertscapes in the company of new documents prove he was an influential artist in his time. Ultimately, it is Lungen's interpretation of the desert that is his final testament. He wrote to George Stevens, "This wonderful desert, this riot of color and light, smiling one moment and a fury the next, days of violet and red gold and nights of velvet, star spangled, alluring, seducing and annihilating, I wish you could see it as I do."[53] Today we can do just that. The legacy of Lungren's vision endures, like an afterglow in the desert.

Jane Dini

46

Scholarly assistance was generously provided by Elizabeth Brown, Marla Berns, Cody Hartley, Gloria Martin, and Bruce Robertson. For help with library and archival materials special thanks to Lee Kimball Clark, Nancy Moure, Michael Redmon, Terri Sheridan, and Jan Timbrook. For help with desert geology thanks to Robert Norris. Conservation questions were generously answered by Travers Newton. For help with desert botany thanks to Dieter H. Wilken and Robert Haller. For help with Santa Barbara history thanks to Judy Brown, Erika Edwards, Buella Moore, and David Myrick. Very special thanks to the painters Michael Drury, Larry Iwerks, Hank Pitcher, Skip Smith, and Ray Strong for their technical expertise and for help identifying desert locales.

1 Fernand Lungren, "The Desert," unpublished manuscript, n.d. Fernard Harvey Lungren Collection, The Huntington Library, San Marino, California, n.p.

2 *The Art Digest*, January 1, 1933, p. 20.

3 One of Lungren's New York acquaintances was fellow artist Robert Frederick Blum, with whom he shared a studio apartment. Bruce Weber, *Robert Frederick Blum (1857–1903) and His Milieu*. Dissertation, The City University of New York, 1985, p. 73.

4 Frances Hodgson Burnett, "Little Saint Elisabeth," *St. Nicholas Magazine*, December 1888, p. 137; H.C. Bunner, "Shantytown," *Scribner's*, October 1880, p. 866.

5 For more on the Tile Club see Ronald G. Pisano, *The Tile Club and the Aesthetic Movement in America*. New York: Abrams, 1999.

6 I am grateful to Michael Drury for pointing out this important detail.

7 A popular novel of the time, Emile Zola's *Au Bonheur des Dames* (The Ladies' Paradise) (1883), examined how the modern department store provided acceptable public spaces for women to appear in without a chaperone.

8 Jesse Walter Fewkes, "The Snake Ceremonials at Walpi," *A Journal of American Ethnology and Archaeology*, Vol. iv, 1894, p. 5.

9 Hamlin Garland, "Among the Moki Indians," *Harper's Weekly*, Vol. 40, August 15, 1896, p. 802.

10 Ibid., p. 806.

11 John A. Berger, *Fernand Lungren: A Biography*. Santa Barbara: The Schauer Press, 1936, p. 63.

12 Fernand Harvey Lungren to George W. Stevens, January 9, 1911, Archives of American Art.

13 According to Berger, p. 56, the painter had read the books of Charles F. Lummis on the plateau deserts.

14 Charles Lummis, *A Tramp Across the Continent*. New York: Charles Scribner's Sons, 1892, reprinted 1917, p. 244.

15 See *Photographed All the Best Scenery: Jack Hillers's Diary of the Powell Expeditions, 1871–1875*. Don D. Fowler, editor. Salt Lake City: University of Utah Press, 1972. See also May Castleberry *et al.*, *Perpetual Mirage: Photographic Narratives of the Desert West*. Exh. cat., Whitney Museum of American Art, 1996.

16 Clarence Dutton's *Tertiary History of the Grand Cañon District with Atlas*. Washington, D.C.: United States Geological Survey, 1882, p. 84. I am very grateful to Kevin Murphy for pointing out this important source.

17 Joshua C. Taylor, *America as Art*. Washington, D.C.: National Collection of Fine Arts, 1976, p. 130. Lungren and Moran would cross paths more than once as they weaved back and forth across the continent. By chance, each would end up in Santa Barbara and it was there, in the last years of their lives, that they became close friends.

18 *Catalogue of Pictures and Studies of the Southwest by Fernand Lungren*. Exh. cat., The American Art Galleries, New York, 1899. In the catalogue it is called *Thirst—The Beginning of the End—Mojave Desert*.

19 Owen Wister, "Thirst," *Harper's Weekly*, Vol. 40, No. 2042, February 8, 1896, p. 126.

20 Owen Wister to Fernand Lungren, August 30, 1911, Lungren Collection, The Huntington Library.

21 Berger, p. 330.

22 Theodore Roosevelt to Fernand Lungren, October 10, 1902, quoted in Berger, p. 126.

23 William Macbeth, *Some Phases of London When the Lamps are Lighted, Done in Pastel by Fernand Lungren*. Exh. cat., Macbeth Gallery, New York, 1902.

24 Fernand Lungren to Charles Lummis, n.d. [1900], The Southwest Museum, Los Angeles, California.

25 Ibid.

26 Fernand Lungren, "Egypt Diary," unpublished manuscript, 1900–01, Lungren Collection, The Huntington Library.

27 Fernand Lungren, "Impressionism," unpublished manuscript, n.d., Lungren Collection, The Huntington Library.

28 Berger, p. 132. George Steckel was a photographer who opened Los Angeles' first art gallery at 336 1/2 South Broadway.

29 Lungren to Stevens, January 9, 1911.

30 Berger, p. 140.

31 Lungren, "The Desert."

32 Berger, p. 131.

33 Many thanks for the generosity of Nancy Moure who shared this information with me.

34 Lungren, "The Desert."

35 Berger, p. 185.

36 *Museum Notes*, Santa Barbara: Santa Barbara Museum of Natural History, October, 1929, unpaged.

37 Fernand Lungren, *Going in to Death Valley*. n.d. Self published. Copy in possession of Santa Barbara Historical Society.

38 Willa Cather, *Death Comes for the Archbishop*, 1927; reprinted New York: Vintage Books, 1990, pp. 94–95.

39 John C. Van Dyke, *The Desert*, 1901; reprinted Salt Lake City: Peregrine Smith, 1987, p. 104.

40 Berger, p. 177.

41 Lungren, "The Desert."

42 According to Donald Myrick, Brett Moore dated the work 1912. Many thanks to David Myrick for sharing this important story.

43 See Charlotte P. Myrick, "Fernand Lungren," *Noticias* (Santa Barbara Historical Society), Vol. X, No. 3, 1964, p. 4.

44 Lungren to Stevens, January 9, 1911.

45 Sarah Burns, *Inventing the Modern Artist: Art and Culture in Gilded Age America*. New Haven: Yale University Press, 1996, p. 58.

46 White to Bernard Hoffman, quoted in Litti Paulding, "Fernand Lungren, Gone from this Scene, Leaves Brighter Glow in the Sunset He was Wont to Paint with Deep Beauty," *Santa Barbara News Press*, Friday, November 25, 1932, p. 5.

47 Lungren also cultivated the taste of his clients. According to Berger, Lungren was "Always on the lookout for native artifacts to be used as Christmas gifts, he found that good silver and blanket work were becoming scarcer every year. But on that side of the reservation he picked up a silver necklace for Miss Bowditch, several good bracelets, Navajo blankets and buttons." Berger, Fernand Lungren, p. 165.

48 Fernand Lungren to Charles Lummis, December 14, 1917, The Southwest Museum Library and Museum.

49 Charles Lummis to Fernand Lungren, December 17, 1917, The Southwest Museum Library and Museum.

50 Gloria Rexford Martin and Michael Redmon, "The Santa Barbara School of the Arts: 1920–1938," *Noticias* (Santa Barbara Historical Society), Vol. XL, Nos. 3,4, 1994, pp. 46–83.

51 Fernand Lungren to Mrs. Hope Henderson, Sunday June 5, 1931. University Art Museum Archives.

52 Fernand Lungren, "Last Will and Testament," November 2, 1932. Copy in possession of The Santa Barbara Historical Society.

53 Lungren to Stevens, January 9, 1911.

PLATE 1
The Gardens of Luxembourg, c. 1882
oil on canvas, 30 1/2 x 58 in.
Courtesy of Spanierman Gallery LLC, New York City
Cat. no. 2

PLATE 2
Bear Hunter, c. 1893/97
oil on canvas, 25 1/4 x 45 in.
Cat. no. 6

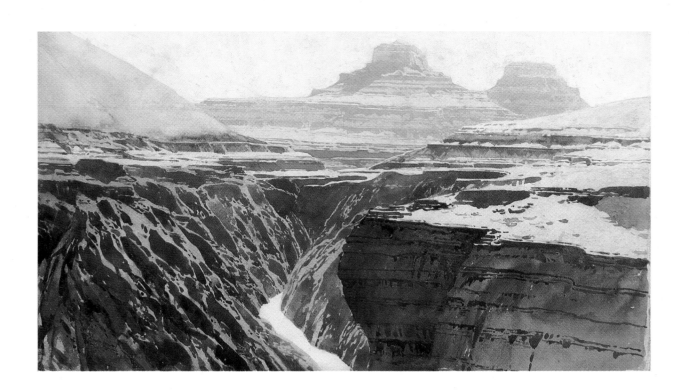

PLATE 3
Above the Inner Gorge, c. 1890s
watercolor, 10 3/4 x 20 in.
Cat. no. 4

51

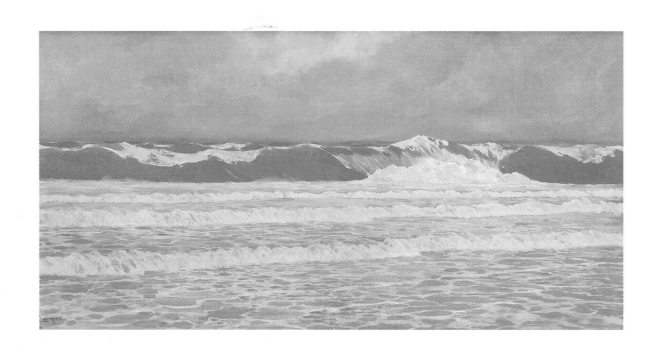

PLATE 4
Surf After Storm, before 1915
oil on canvas, 18 x 36 in.
Cat. no. 50

52

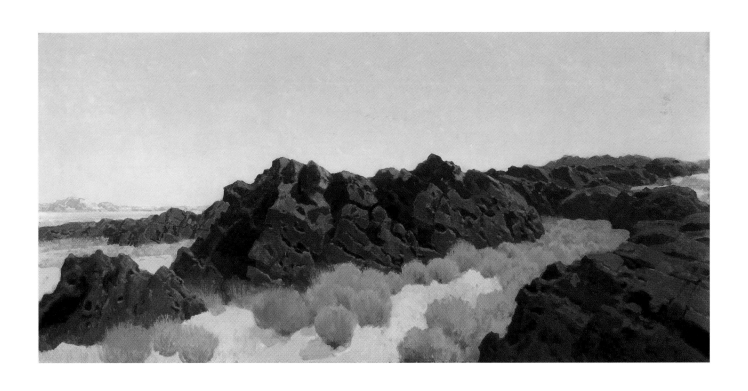

PLATE 5
Rivers of Stone, before 1899
oil on canvas, 24 1/8 x 50 1/8 in.
Cat. no. 12

53

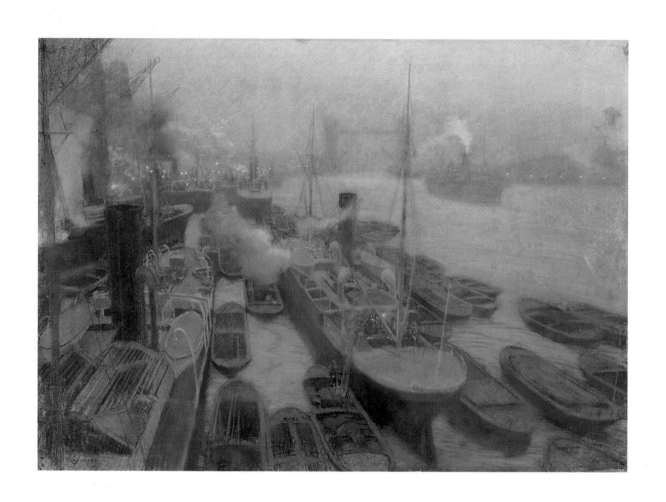

PLATE 6
Pool and Tower Bridge, c. 1899/1901
pastel, 15 x 21 1/2 in.
Cat. no. 17

54

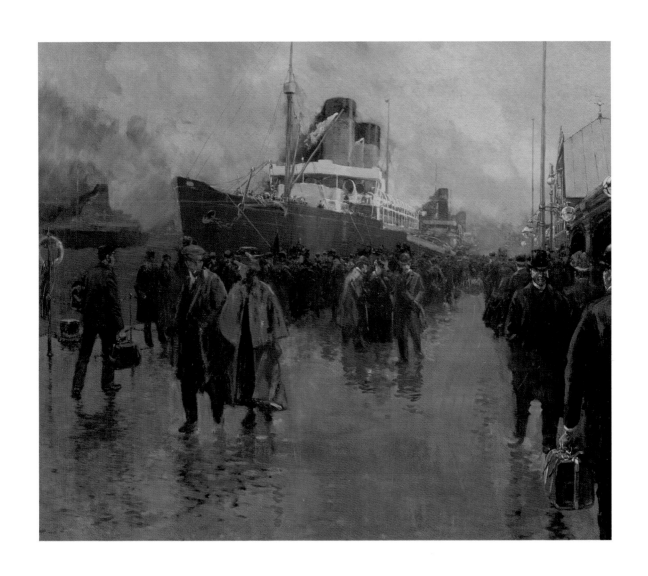

PLATE 7
Liverpool (Docking a Liner), c. 1899/1901
oil on canvas, 30 x 36 in.
Cat. no. 14

55

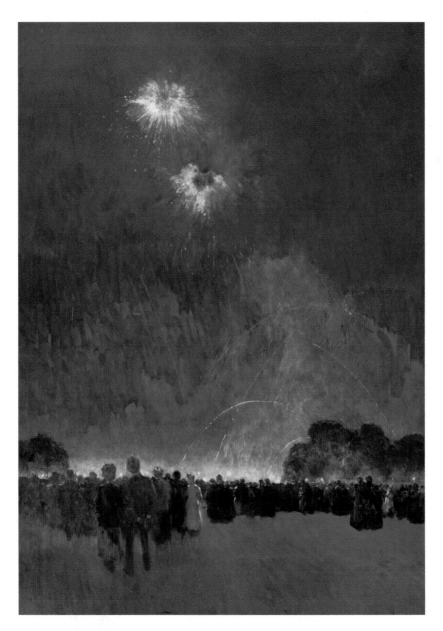

PLATE 8
Rockets, c. 1899/1901
oil on canvas, 40 1/4 x 30 1/4 in.
Cat. no. 15

PLATE 9
Along the Shore, 1901
oil on canvas, 18 x 36 in.
Cat. no. 21

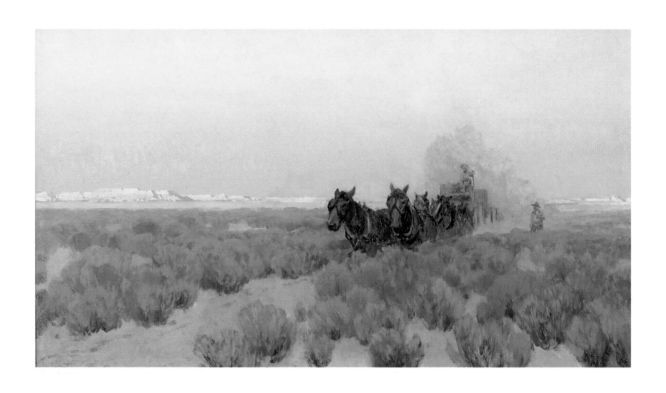

PLATE 10
The Freighter, c. 1903/06
oil on canvas, 25 x 45 in.
Cat. no. 29

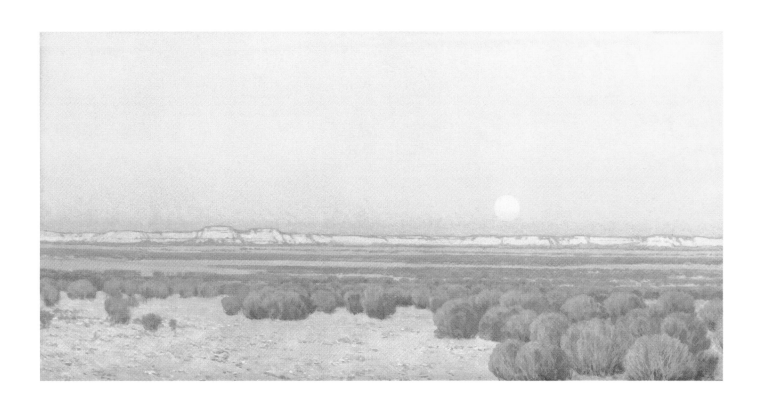

PLATE 11
Moonrise at the White Mesa, Arizona, 1904
oil on canvas, 20 x 40 in.
Cat. no. 31

59

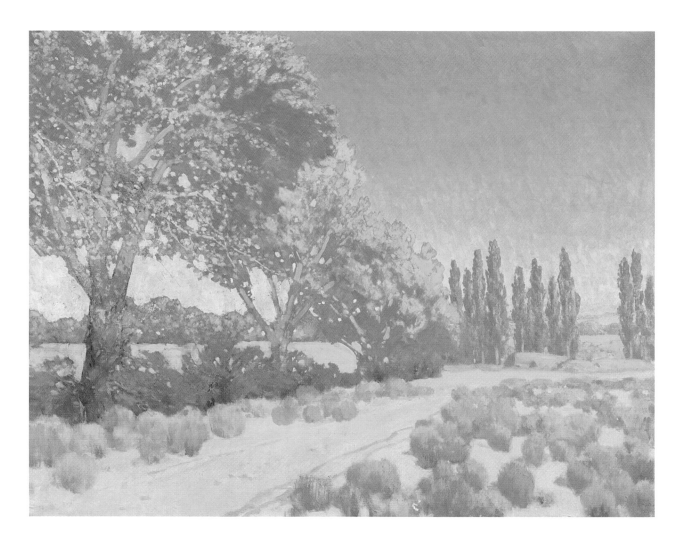

PLATE 12
Road to the Corral, c. 1903/10
oil on canvas, 30 1/4 x 40 1/8 in.
Cat. no. 30

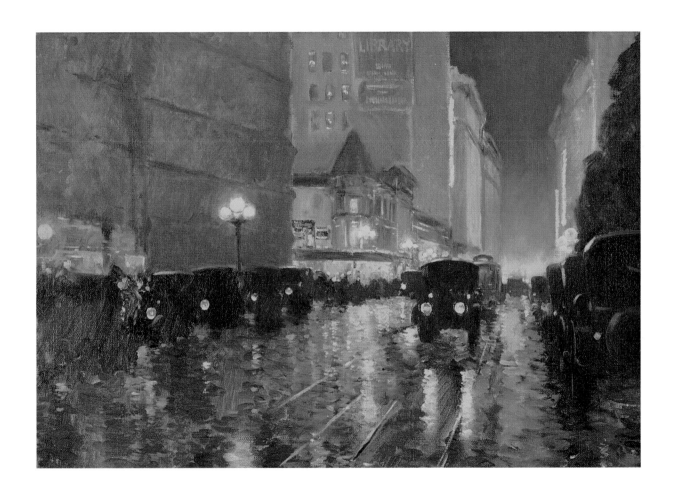

PLATE 13
Fifth Street at Hill: Looking East, Evening, c. 1909
oil on canvas, 14 x 19 1/4 in.
Cat. no. 27

61

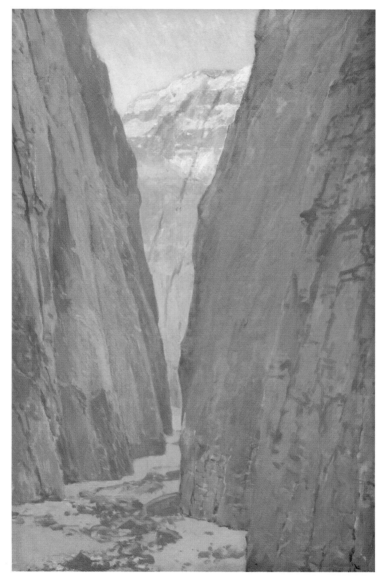

PLATE 14
Desert Gorge: Calico, no date
oil on canvas, 30 x 20 in.
Cat. no. 26

62

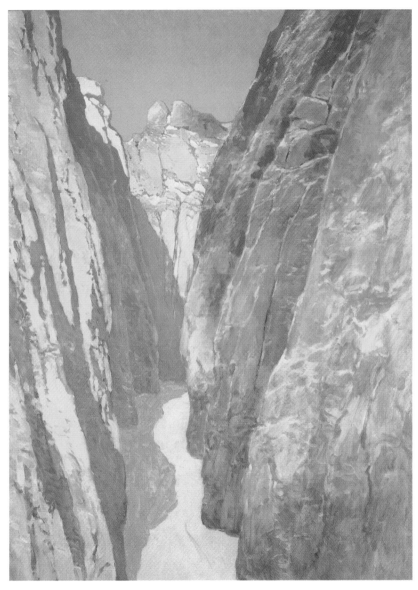

PLATE 15
Desert Gorge: Wall Street Canyon, no date
oil on canvas, 36 x 27 in.
Cat. no. 25

63

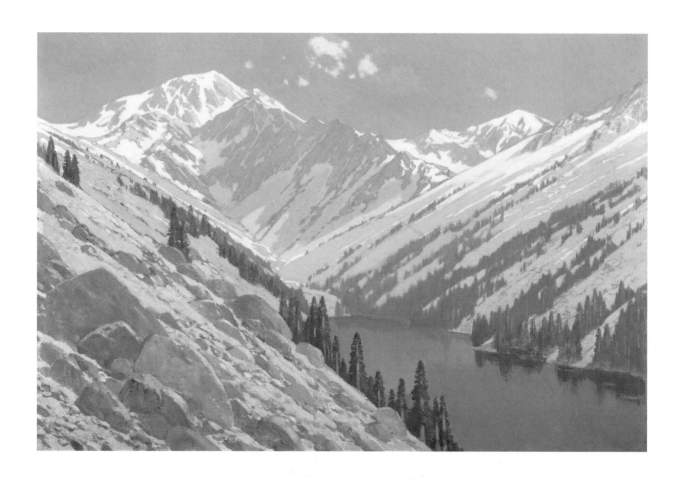

PLATE 16
Mountain Lake: High Sierra, c. 1904/05 or later
oil on canvas, 30 1/4 x 45 in.
Cat. no. 34

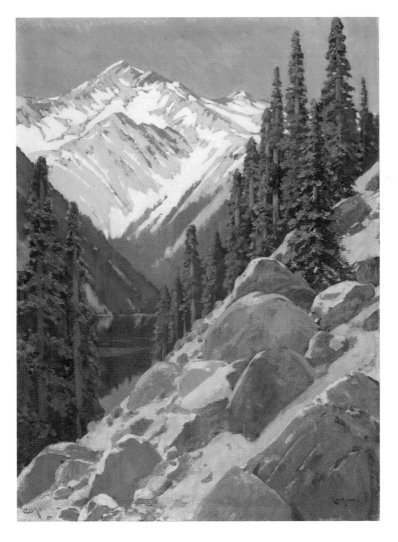

PLATE 17
In the High Sierras, c. 1904/05
oil on canvas, 24 1/4 x 18 in.
Cat. no. 33

65

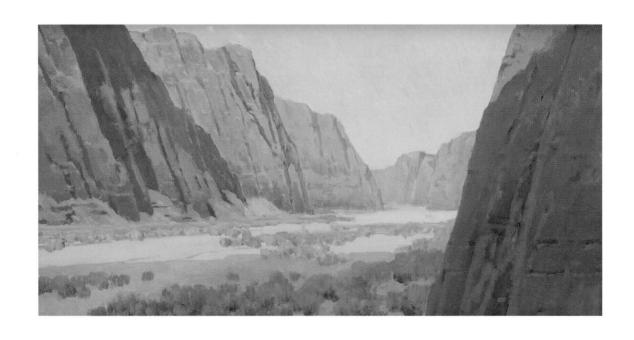

PLATE 18
Canyon de Chelly, c. 1903/06
oil on canvas, 18 3/16 x 36 in.
Cat. no. 28

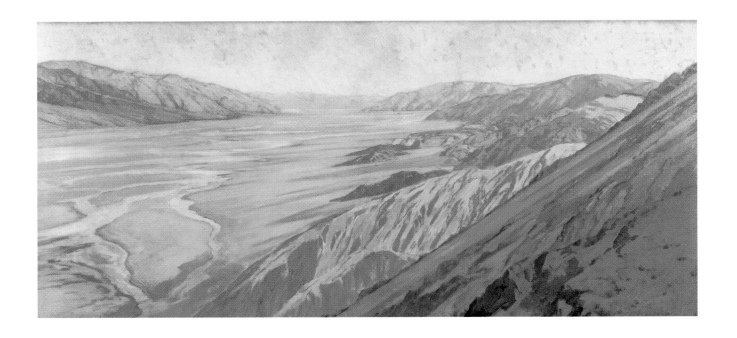

PLATE 19
Death Valley: Dante's View, c. 1908/10
oil on canvas, 26 1/4 x 60 1/4 in.
Cat. no. 38

67

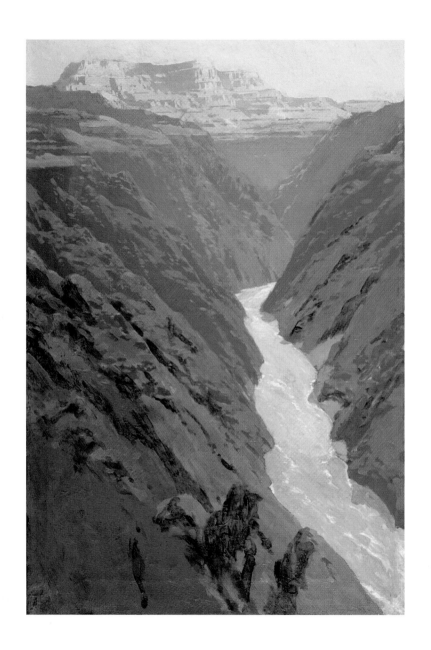

PLATE 20
Silver River, no date
oil on canvas, 24 x 16 in.
Cat. no. 37

68

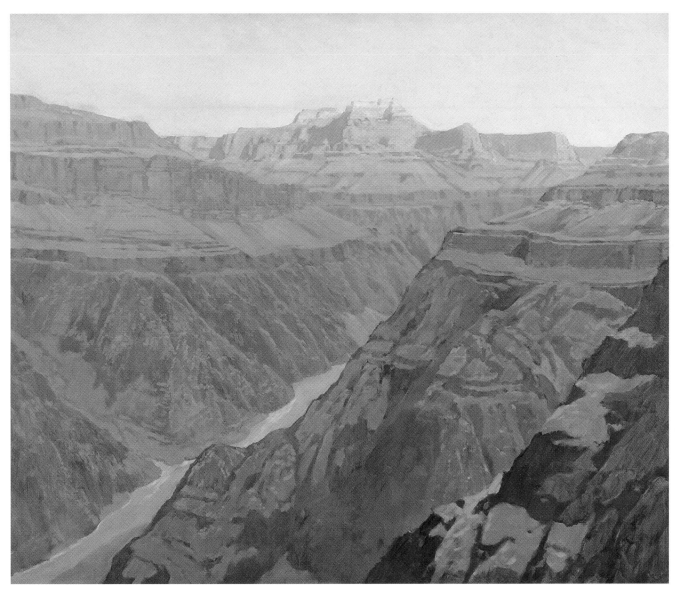

PLATE 21
Grand Canyon, c. 1910
oil on canvas, 30 x 36 in.
Cat. no. 40

69

PLATE 22
Aspens in the Snow, no date
oil on canvas, 20 x 15 in.
Cat. no. 56

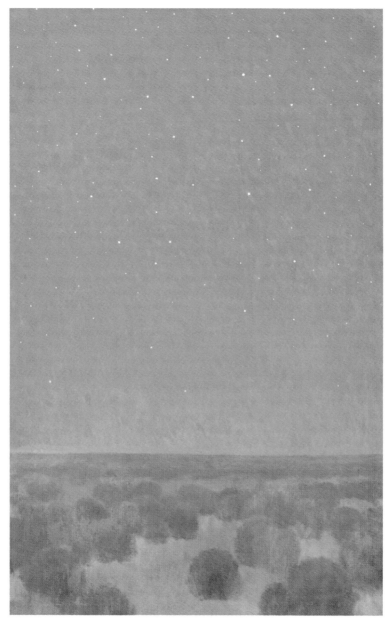

PLATE 23
Starlight in the Desert, c. 1910
oil on canvas, 42 1/2 x 27 1/4 in
Cat. no. 39

71

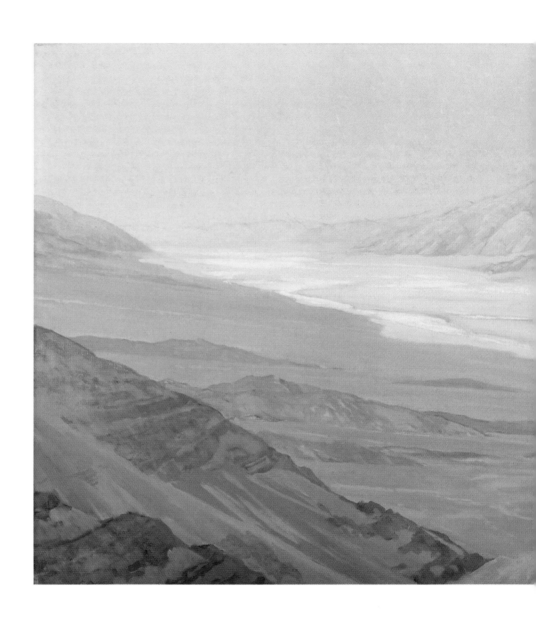

PLATE 24
Death Valley (Morning), c. 1928
oil on canvas, 26 1/4 x 60 1/4 in.
Cat. no. 64

72

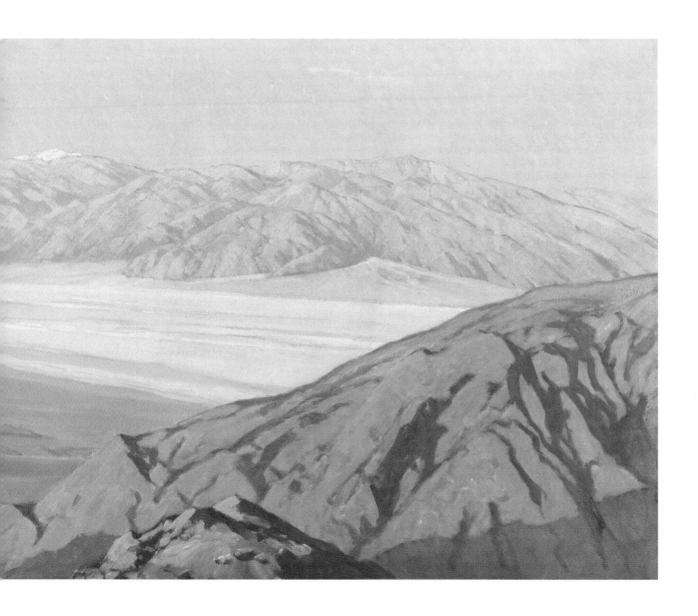

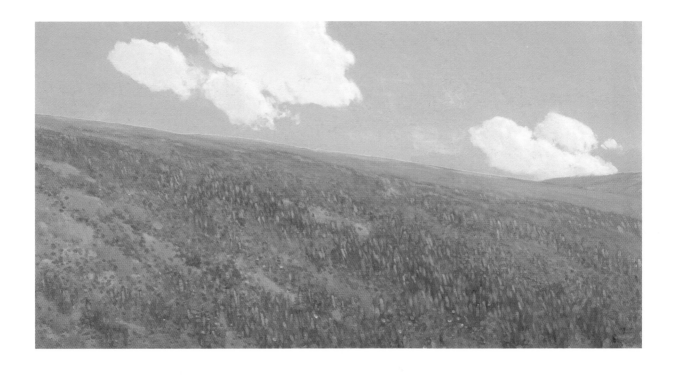

PLATE 25
Poppies and Lupin, 1912
oil on canvas, 22 1/8 x 42 in.
Cat. no. 48

74

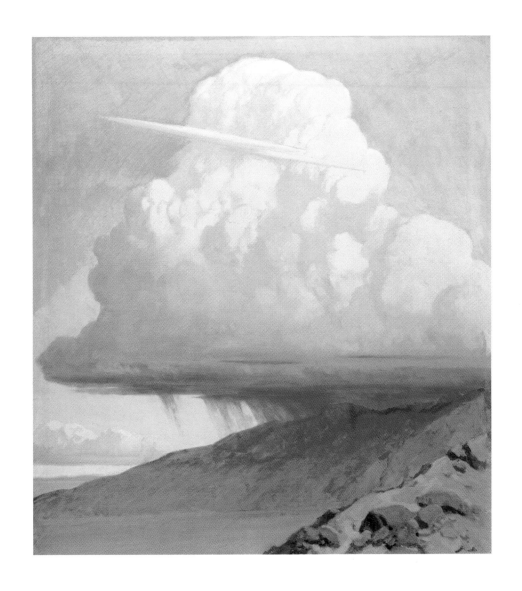

PLATE 26
A Cloudburst, c. 1915
oil on canvas, 40 x 36 in.
Cat. no. 51

75

PLATE 27
Sands of Silence, c. 1911
oil on canvas, 27 1/4 x 50 1/4 in.
Cat. no. 45

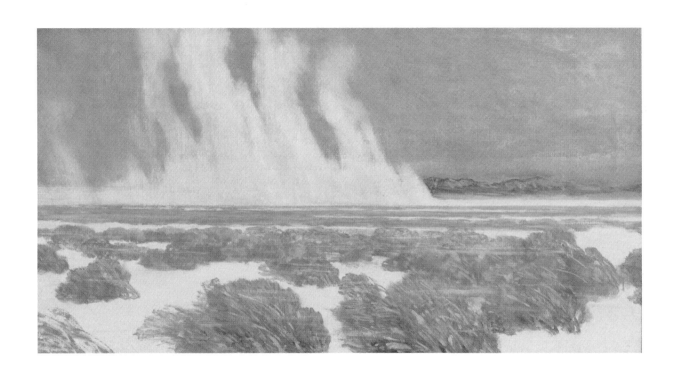

PLATE 28
Sand Specters: Death Valley, 1910s
oil on canvas, 20 1/8 x 38 in.
Cat. no. 44

PLATE 29
The Carpet of the Desert (Evening), 1920s
oil on canvas, 24 3/8 x 50 1/4 in.
Cat. no. 57

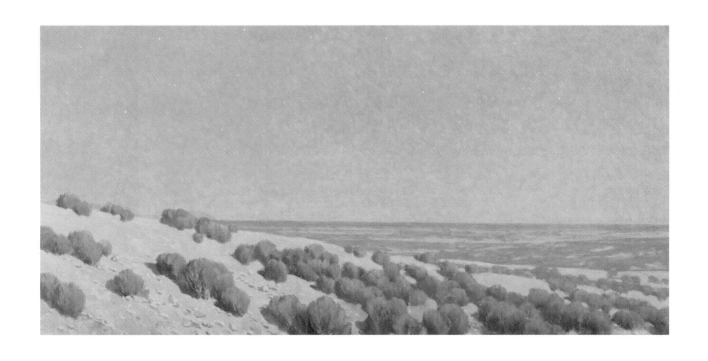

PLATE 30
Full Moon in the Mojave Desert, no date
oil on canvas, 24 x 50 in.
Cat. no. 61

79

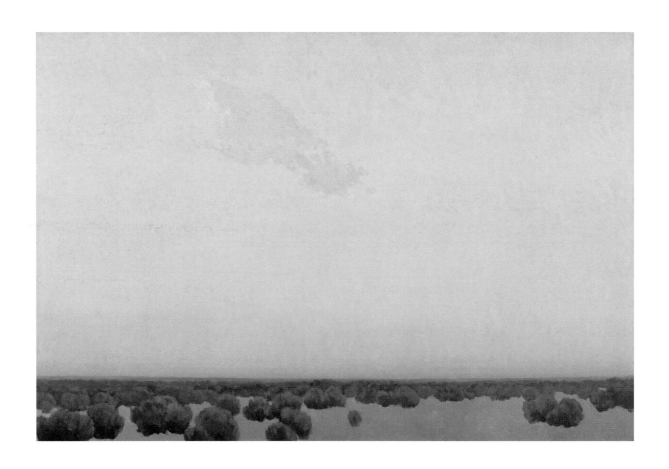

PLATE 31
Pink Cloud, no date
oil on canvas, 30 x 45 in.
Cat. no. 60

80

Catalogue of the Exhibition

All dimensions given in inches, height before width before depth. All works, unless noted otherwise, are from the University Art Museum, University of California, Santa Barbara. All object numbers refer to the University Art Museum's acquisition numbers. Objects from the Collection of the Santa Barbara Museum of Natural History are denoted SBMNH.

1. *The Bull Calf*, c. 1880
watercolor, 10 x 14
Fernand Lungren Bequest, 1964.829

2. *The Gardens of Luxembourg*, c. 1882
oil on canvas, 30 1/2 x 58
Courtesy of Spanierman Gallery, New York
PLATE 1

3. *Aspens*, c. 1890
watercolor, 21 7/16 x 14 1/2
Fernand Lungren Bequest, 1964.833

4. *Above the Inner Gorge*, 1890s
watercolor, 10 3/4 x 20
Fernand Lungren Bequest, 1964.826
PLATE 3

5. *Thirst*, c. 1893/97
oil on canvas, 27 1/8 x 50 1/4
Fernand Lungren Bequest, 1964.692
p. 36

6. *Bear Hunter*, c. 1893/97
oil on canvas, 25 1/4 x 45
Fernand Lungren Bequest, 1964.749
PLATE 2

7. *In the Abyss: Grand Canyon*, c. 1895/97
oil on canvas, 60 1/4 x 40
Fernand Lungren Bequest, 1964.659
p. 28

8. *Yellow Blanket*, c. 1895
watercolor, 17 1/2 x 13
Fernand Lungren Bequest, 1964.822
conserved with help from Joseph and Helene Pollock
p. 19

9. *Dance Court, Walpi*, c. 1895
watercolor, 11 3/4 x 17 3/4
Fernand Lungren Bequest, 1964.832
p. 32

10. *The Crier*, c. 1895/99
oil on canvas, 40 x 34 1/2
Collection of SBMNH

11. *Entrance to Canyon del Muerto from Canyon de Chelly*, c. 1897
oil on canvas, 20 1/4 x 38 1/8
Fernand Lungren Bequest, 1964.690
p. 33

12. *Rivers of Stone*, before 1899
oil on canvas, 24 1/8 x 50 1/8
Fernand Lungren Bequest, 1964.691
PLATE 5

13. *The Arm of the Law/ Hyde Park Corner, London*, c. 1899/1901
oil on canvas, 24 1/4 x 36 1/8
Fernand Lungren Bequest, 1964.636
p. 40

14. *Liverpool (Docking a Liner)*, c. 1899/1901
oil on canvas, 30 x 36
Fernand Lungren Bequest, 1964.654
PLATE 7

15. *Rockets,* c. 1899/1901
oil on canvas, 40 1/4 x 30 1/4
Fernand Lungren Bequest, 1964.702
PLATE 8

16. *Earls Court: London,* c. 1899
pastel, 18 3/4 x 24 3/4
Fernand Lungren Bequest, 1964.814
conserved with help from Gary Breitweiser
p. 37

17. *Pool and Tower Bridge,* c. 1899/1901
pastel, 15 x 21 1/2
Fernand Lungren Bequest, 1964.812
PLATE 6

18. *Piccadilly Slope,* c. 1899/1901
pastel, 20 x 15
Fernand Lungren Bequest, 1964.813
conserved with help from Eva and Yoel Haller
p. 29

19. *Passing Train: England,* c. 1899/1901
pastel, 9 5/16 x 12 7/16
Fernand Lungren Bequest, 1964.815

20. *Gebel Turah,* 1901
pastel, 10 x 21 1/2
Fernand Lungren Bequest, 1964.803
p. 20

21. *Along the Shore,* 1901
oil on canvas, 18 x 36
Fernand Lungren Bequest, 1964.645
PLATE 9

22. *Pyramids,* 1901
oil on canvas, 20 x 29 3/4
Fernand Lungren Bequest, 1964.747
p. 39

23. *Building the Subway New York, no. 1,* 1902
charcoal and wash, 24 3/4 x 19
Fernand Lungren Bequest, 1964.846

24. *Building the Subway New York, no. 2,* 1902
charcoal and wash, 28 3/4 x 21 1/2
Fernand Lungren Bequest, 1964.847
conserved with help from Deanne and James Dehlsen

25. *Desert Gorge: Wall Street Canyon*
oil on canvas, 36 x 27
Collection of Bob and Marlene Veloz
PLATE 15

26. *Desert Gorge: Calico*
oil on canvas, 30 x 20
Fernand Lungren Bequest, 1964.667
PLATE 14

27. *Fifth Street at Hill: Looking East, Evening,*
c. 1909
oil on canvas board, 14 x 19 1/4
Fernand Lungren Bequest, 1964.781
PLATE 13

28. *Canyon de Chelly,* c. 1903/06
oil on canvas, 18 3/16 x 36
Fernand Lungren Bequest, 1964.723
PLATE 18

29. *The Freighter,* c. 1903/06
oil on canvas, 25 1/4 x 45 1/8
Fernand Lungren Bequest, 1964.717
PLATE 10

30. *Road to the Corral*, 1903/10
oil on canvas, 30 1/4 x 40 1/8
Fernand Lungren Bequest, 1964.712
PLATE 12

31. *Moonrise at the White Mesa, Arizona*, 1904
oil on canvs, 20 x 40
Fernand Lungren Bequest, 1964.634
PLATE 11

32. *From the Valley of the Shadow (Sierras)*, c. 1904/05
oil on canvas, 25 x 45
Fernand Lungren Bequest, 1964.655

33. *In the High Sierras*, c. 1904/05
oil on canvas, 24 1/4 x 18
Fernand Lungren Bequest, 1964.656
PLATE 17

34. *Mountain Lake: High Sierra*, c. 1904/05
oil on canvas, 30 1/4 x 45
Fernand Lungren Bequest, 1964.689
PLATE 16

35. *Wagon Train*, c. 1905
oil on canvas, 16 x 26
Collection of Bob and Marlene Veloz
p. 15

36. *The Bell Mare*, c. 1905
oil on canvas, 24 x 16
Fernand Lungren Bequest, 1964.818

37. *Silver River*
oil on canvas, 24 x 16
Fernand Lungren Bequest, 1964.680
PLATE 20

38. *Death Valley: Dante's View*, c. 1908/10
oil on canvas, 26 1/4 x 60 1/4
Fernand Lungren Bequest, 1964.652
PLATE 19

39. *Starlight in the Desert*, c. 1910
oil on canvas, 42 1/4 x 27 1/2
Fernand Lungren Bequest, 1964.635
PLATE 23

40. *Grand Canyon*, c. 1910
oil on canvas, 30 x 36
Fernand Lungren Bequest, 1964.696
PLATE 21

41. *Study for Death Valley (Toledo)*, c. 1910
oil on board, 19 7/8 x 29 7/8
Fernand Lungren Bequest, 1964.658

42. *Quick Sketch Inyo Range*, 1910s
oil on canvas, 13 1/2 x 19
Fernand Lungren Bequest, 1964.755

43. *Thunder Heads*, 1910s
oil on board, 12 1/2 x 23
Fernand Lungren Bequest, 1964.782
p. 16

44. *Sand Specters: Death Valley*, 1910s
oil on canvas, 20 1/8 x 38
Fernand Lungren Bequest, 1964.640
PLATE 28

45. *Sands of Silence*, c. 1911
oil on canvas, 27 1/4 x 50 1/4
Fernand Lungren Bequest, 1964.629
PLATE 27

46. *Snow Squall*, c. 1911
oil on canvas board, 14 x 19
Fernand Lungren Bequest, 1964.771

47. *Snow Squall in the Range—Sierra*, c. 1911
oil on canvas board, 12 x 17 3/8
Fernand Lungren Bequest, 1964.784

48. *Poppies and Lupin*, 1912
oil on canvas, 22 1/8 x 42
Fernand Lungren Bequest, 1964.649
PLATE 25

49. *Giant Cactus: Arizona no. 1*, c. 1912
oil on canvas board, 18 3/4 x 13 3/4
Fernand Lungren Bequest, 1964.768

50. *Surf After Storm*, before 1915
oil on canvas, 18 x 36
Fernand Lungren Bequest, 1964.633
PLATE 4

51. *A Cloudburst*, c. 1915
oil on canvas, 40 x 36
Fernand Lungren Bequest, 1964.653
PLATE 26

52. *Arm of the Grand Canyon*
oil on canvas, 25 x 45
Fernand Lungren Bequest, 1964.705

53. *Inyo Range*, c. 1918/20
oil on canvas, 31 5/8 x 60
Fernand Lungren Bequest, 1964.746

54. *Lava in the Desert / In the Valley of the Shadow*, 1920s
oil on canvas, 25 1/4 x 45
Fernand Lungren Bequest, 1964.708

55. *Sierra Nevada*, 1920s
oil on canvas, 20 x 40
Fernand Lungren Bequest, 1964.630

56. *Aspens in the Snow*
oil on canvas, 20 x 15
Fernand Lungren Bequest, 1964.748
PLATE 22

57. *The Carpet of the Desert (Evening)*, 1920s
oil on canvas, 24 3/8 x 50 1/4
Fernand Lungren Bequest, 1964.641
PLATE 29

58. *Desert Sand (Evening)*, 1920s
oil on canvas, 18 1/8 x 36
Fernand Lungren Bequest, 1964.648
p. 25

59. *Afterglow in the Desert*
oil on canvas, 24 1/4 x 18
Fernand Lungren Bequest, 1964.675
p. 12

60. *Pink Cloud*
oil on canvas, 30 x 45
Fernand Lungren Bequest, 1964.701
PLATE 31

61. *Full Moon in the Mojave Desert*
oil on canvas, 24 x 50
Fernand Lungren Bequest, 1964.639
PLATE 30

62. *Rose Buttes, Moonlight*
oil on canvas, 24 x 36
Fernand Lungren Bequest, 1964.657

63. *Silent Sea*, c. 1926/30
oil on canvas, 30 x 40
Fernand Lungren Bequest, 1964.713
p. 24

64. *Death Valley (Morning)*, c. 1928
oil on canvas, 26 1/4 x 60 1/4
Fernand Lungren Bequest, 1964.644
PLATE 24

65. *Lungren Home: Mission Canyon*, c. 1932
oil on canvas, 24 x 20
Fernand Lungren Bequest, 1964.736
p. 23

RELATED OBJECTS

66. Sketchbook, "Jots from Nature," 1877
Inscribed "Fred" Lungren, 14 x 20 3/4
Courtesy of Kennedy Galleries, New York

67. Frank Morley Fletcher
Portrait of Fernand Lungren, c. 1920
oil on canvas, 24 1/2 x 17 1/2
Collection of Santa Barbara Museum of Art

68. Photographer Unknown
Fernand Lungren in London with Arm of the Law,
1899
gelatin silver print, 6 1/8 x 4 1/2
p. 8

69. Photographer Unknown
Henrietta Lungren at the Grand Canyon, 1903
gelatin silver print, 6 7/8 x 4 13/16

70. Photographer Unknown
Henrietta Lungren on Bass Trail, Grand Canyon, 1903
gelatin silver print, 4 15/16 x 6 13/16

71. Obert's Photo Studio, Santa Barbara
Corner of Lungren's Mission Canyon Studio, c. 1920
gelatin silver print, 6 3/4 x 4 7/8

72. Obert's Photo Studio, Santa Barbara
*Corner of Lungren's Studio with Fireplace and Indian
Artifacts*, c. 1920
gelatin silver print, 4 13/16 x 6 7/8
p. 87

73. Obert's Photo Studio, Santa Barbara
Fireplace in Lungren's Studio with Santa Clara Pot,
c. 1920
gelatin silver print, 6 3/4 x 4 3/4
p. 44

74. Photographer Unknown
Portrait of Fernand Lungren with In the Abyss, 1920s
gelatin silver print, 9 3/8 x 7 7/8
p. 4

75. Jesse Walter Fewkes
"The Snake Ceremonials at Walpi," *A Journal of
American Ethnology and Archaeology* Vol. iv, 1894
Inscribed by Fernand Lungren
Collection of SBMNH

76. Fernand H. Lungren (author and illustrator)
"The Magic Turquoise," *St. Nicholas Magazine*
Vol. 23, January 1896, p. 216–22
Courtesy Santa Barbara Public Library

77. Andrew Ruhl
"Building New York's Subway," *Century Magazine*
Vol. 64, October 1902, pp. 894–911
Courtesy UCSB Library

78. Hamlin Garland
"Among the Moki Indians," *Harper's Weekly*
Vol. 40, August 15, 1896, pp. 801–807

79. H.C. Bunner
"Shantytown," *Scribner's Monthly*
Vol. 20, October 1880, pp. 855–869
Courtesy UCSB Library

80. Apache
Spoon
Mountain Sheep horn, 14 3/4 x 5 3/4
Collection of SBMNH

81. Hopi
Coiled Tray Basket
yucca strips on grass bundle foundation
15 3/4 diameter
Collection of SBMNH

82. Hopi
Kachina Doll
wood and paint, 9 3/4 x 3 x 2
Collection of SBMNH

83. Hopi
Kachina Tiles (10)
ceramic, 3 x 3 or 6 x 3
Collection of SBMNH

84. Hopi
Pottery Bowl
ceramic, 8 3/4 diameter
Collection of SBMNH

85. Kiowa
Moccasins
rawhide deerskin, beads, and paint, 11 1/2 x 4 x 3
Collection of SBMNH

86. Navajo
Silver Squash Blossom Necklace
silver and turquoise, 17 long
Collection of SBMNH

87. Navajo
Water Bottle Basket
sumac and pine pitch, horsehair, sisal twine, and wire
14 x 10
Collection of SBMNH

88. Pima
Basket Tray
willow and devil's claw, cattail foundation, 17 diameter
Collection of SBMNH

89. Santa Clara
Pottery Vessel
ceramic, 16 diameter
Collection of SBMNH

90. Yuma / Mojave
Clay Figurine
earthenware and beads, 6 x 2 1/2 x 1 1/2
Collection of SBMNH

A Chronology of Fernand Lungren's Life and Work

Cody J. Hartley

1857

NOVEMBER 13. Fernand Harvey Lungren born to Dr. and Mrs. Samuel S. Lungren in Hagerstown, Maryland. Dr. Lungren was a descendent of the 17th-century Swedish settlers of Fort Christina on the Delaware River. Mrs. Lungren was also of Swedish descent.

1861

The Lungren family moves to Toledo, Ohio, where Dr. Lungren re-establishes his medical practice.

1862

Homestead Act passed by Congress providing settlers 160 acres of free public land after five years of residence.

1864

NOVEMBER. Several hundred Cheyenne and a smaller number of Arapaho Indians massacred in a surprise attack at Sand Creek in Colorado Territory while negotiating for peace.

1868

14th Amendment grants US citizenship to all individuals born on American soil, in theory; while including African Americans it excludes Native Americans.

1869

MAY 10. Union Pacific and Central Pacific Railroads meet in Promontory, Utah. First transcontinental railway is complete.

MAY 24. John Wesley Powell's crew leaves Green River, Wyoming, for a three-month expedition down the Green and Colorado River. Powell's expedition is the first to explore the full length of the Grand Canyon.

1871

Timothy O'Sullivan takes the first photographs of the Grand Canyon.

1873

Thomas Moran joins John Wesley Powell's expedition into Utah and to the North Rim of the Grand Canyon.

1874

SPRING. Fernand Lungren finishes high school at the age of 16. He spends the following summer working as a bank clerk and sketching on the backs of customers' checks in his spare time.

FALL. Lungren enters the University of Michigan in Ann Arbor, registering for courses in mining engineering. Marshall Lungren, Fernand's older brother, is already there working on a civil engineering degree. Lungren provides illustrations to the college paper and works in the University's Natural History Museum.

1876

SPRING. His coursework incomplete, Lungren leaves the University of Michigan with hopes of becoming an artist. He returns to Toledo to seek his father's financial support and finds his parents have separated.

SUMMER. Kenyon Cox and Fernand Lungren meet in Toledo. Lungren unsuccessfully appeals to his father to fund a trip to Paris to follow Cox to the French ateliers. Following a series of his son's unsuccessful attempts at employment, Dr. Lungren eventually agrees to assist him in an art career. It is too late for

Lungren's studio
Cat. no. 72

87

Lungren to join Cox, so he instead goes to Cincinnati, where he meets Alfred Laurens Brennan and Robert Blum. They convince him to follow them to the Pennsylvania Academy to study under Thomas Eakins.

JUNE 25. Northern Plains Indians outmaneuver Lieutenant Colonel George A. Custer and his troops in the Battle of the Little Big Horn. The event marked the height of Indian power in the 19th century, but White reaction to the slaying of Custer and his men led to increasing intolerance and an overwhelming military deployment against the Dakota and Cheyenne Indians involved in the conflict.

1877
After several months of assisting Blum with illustrations, Lungren submits several of his own to *Scribner's*. In the winter of 1877, Lungren arrives in New York to sell his illustrations. At *Scribner's* he meets Alexander W. Drake, a technologically innovative art editor who is credited with helping to usher in "The Golden Age of Illustration." Drake is a life-long supporter and friend.

1878
Several young New York illustrators form the Tile Club as an association of like-minded and fun-loving artists with an interest in decorative and fine art.

Edison Electric Light Company founded in New York.

1879
John Wesley Powell takes leadership of the newly founded Bureau of American Ethnology.

The Atchinson, Topeka, and Santa Fe Railway (AT&SF) sends its first passenger train into New Mexico.

FEBRUARY. *Scribner's Monthly* publishes Lungren's first three illustrations to accompany an Allen C. Redwood story, "Fortunes and Misfortunes of Company 'C'" (Vol. 17, pp 528–537).

SEPTEMBER. Lungren begins providing illustrations for *St. Nicholas*, a children's magazine published by Scribner's.

1880
Lungren and Robert Blum rent a studio together on Washington Square in New York City.

APRIL 5 – MAY 30. *Snake Rail Fence* (black and white) exhibited at the Pennsylvania Academy of Fine Arts (PAFA) 51st annual exhibition.

1881
Helen Hunt Jackson's *A Century of Dishonor: A Sketch of the United States Government's Dealings With Some of the Indian Tribes* published, lambasting the government's treatment of Native Americans.

AT&SF completes the line from Las Vegas, NM, to Deming, NM, where it connects with the Southern Pacific to complete a southern transcontinental railroad route.

JANUARY. The Hinds and Ketcham building in New York becomes the first electrically lit building.

APRIL 4 – MAY 29. *Mall Coach* (pen and ink) exhibited at the 52nd PAFA annual exhibition.

1882
Senator Benjamin Harrison introduces a bill to make the Grand Canyon a national park. It would be reintroduced in 1883 and 1886 before Harrison successfully creates the Grand Canyon Forest Reserve in 1893.

JUNE 3. Members of the Tile Club leave for Paris and invite Lungren to join them. On the trip with Lungren are A.A. Anderson, J. Carroll Beckwith, William M. Chase, Arthur Quarterly, Frederic P. Vinton, and Blum. The group lands in Antwerp and then travels to Paris, where Lungren and Kenyon Cox are reunited. Cox introduces Lungren to the Parisian salons and ateliers, including the Académie Julian. Lungren visits Fontainebleau and Barbizon while summering at Grez-sur-Loing and remains in Paris for two years.

SEPTEMBER. Built under Edison's direct supervision, the world's first power plant is opened for commercial operation in lower Manhattan.

1883
Joseph Henry Sharp travels throughout the Southwest and Northwest.

Harmony Borax Works begins a short-lived mining operation in Death Valley. While the mine survived only five

years, the 20-mule wagon teams were immortalized in later advertising campaigns for the Pacific Coast Borax Company.

1884
Lungren returns to America, staying briefly in New York and Chicago before settling in Cincinnati to teach and work.

Helen Hunt Jackson publishes *Ramona*, a fictionalized account of Indian life in old California.

JANUARY. *Century Magazine* publishes "Log of an Ocean Studio," written by C.C. Buel with illustrations by members of the Tile Club (Vol. 27, pp. 356–371). The article retells the events of their Atlantic crossing and includes Lungren's drawing, *In the Furnace Hold*.

SEPTEMBER 12. Charles F. Lummis leaves Chillicothe, Ohio, for his "tramp across the continent," arriving in Los Angeles on February 1, 1885.

1886
JANUARY 5 – FEBRUARY 13. *Wet. An Effect* (oil) exhibited at the Boston Art Club (BAC) annual exhibition. The exhibition record lists a Boston address for Lungren.

1887
The Dawes General Allotment Act provides for citizenship and property rights for Native Americans. The act severely disrupts tribal structure, leaving many Native Americans vulnerable to unscrupulous land speculators. "Surplus" land not distributed to individuals is made available to Whites. By 1932, Whites would acquire two thirds of the 138,000,000 acres held by Native Americans in 1887.

1888
Theodore Roosevelt's *Ranch Life and the Hunting Trail* published with illustrations by Frederick Remington.

1889
Theodore Roosevelt's *Winning of the West* published by P. F. Collier & Co.

APRIL 13– MAY 25. *Depot Yard at Night, End of a Bad Day,* and *Snowy Night* exhibited in the 2nd Annual Exhibition of Watercolors by American Artists at the Art Institute of Chicago (AIC).

APRIL 22. Settlers rush to claim 2,000,000 acres of former Indian Territory opened by Congress in Oklahoma. This reversal of the 1828 Congressional act reserving Oklahoma for Native Americans had begun during the Civil War when the five Native American nations living in Oklahoma were placed under military rule. The 1889 land grab capped over a decade of eroding power and property rights for Native Americans in Oklahoma.

1890
US Census officials declare the frontier closed, a declaration made famous by historian Frederick Jackson Turner in an address presented at the 1893 World's Columbian Exposition in Chicago.

C. Scribner's Sons publishes Jacob Riis's *How the Other Half Lives*, featuring his photographs of New York tenements.

DECEMBER 29. Over 200 Sioux men, women, and children massacred by US troops at Wounded Knee in South Dakota.

1891
MARCH 23 – APRIL 19. *A Snowy Night, Madison Square, New York* exhibited at the AIC's 3rd Annual Exhibition of Watercolors.

1892
MARCH 6. Lungren's father dies in Toledo, leaving a small inheritance to Fernand.

SPRING. Lungren meets William H. Simpson, publicity manager for the Santa Fe Railroad. As was done for other artists of the period, Simpson offers to cover Lungren's travel costs to the Southwest in exchange for wash drawings of the region and its inhabitants.

SUMMER AND FALL. Lungren makes his first journey to the Southwest. Illustrations from this trip are published with images by Thomas Moran and H.F. Farny in an 1893 Santa Fe Railway guidebook, *Grand Cañon of the Colorado River, Arizona*, by C. A. Higgins. Over the course of eight months Lungren produces 38 paintings and wash drawings for the Santa Fe.

WINTER. Returning to Cincinnati, Lungren chairs a local art exhibition and shares his sketches and studies with other locals, including J. Henry Sharpe. He corresponds with

John G. Burke, US Army Captain and student of the Hopi Snake Dance, who encourages him to visit the Hopi and paint the Snake Dance.

1893
JUNE. Lungren makes his second trip to New Mexico. Stopping in Chicago to see one of his southwestern paintings at the Columbian Exposition, he learns the Santa Fe Railway has extended his terms indefinitely. He meets Will C. Barnes, Arizona's commissioner to the fair, who invites Lungren to visit him at the Barnes ranch near Holbrook.

AUGUST 6. Hopi Snake Dance ceremonies begin at Walpi. Lungren, in the company of ethnologists A. M. Stephen and J. Walter Fewkes, stays at Walpi to observe the ceremony. He is adopted into the clan of the Honani, or Badger, allowing him to join Stephen and Fewkes in observing secret kiva rituals.

1894–1897
Lungren continues to make annual trips to Arizona and New Mexico while wintering in Cincinnati or New York.

1894
APRIL 7 – 28. *An American Arab-Navajo* (watercolor) exhibited at the BAC annual. Lungren's address is listed in the exhibition record as Cincinnati, Ohio.

1895
From a Bridge and *The Trail of the "High Place"* exhibited at the National Academy of Design (NAD) annual exhibition.

JANUARY. Lungren meets his future wife, Miss Henrietta Whipple.

APRIL 11 – MARCH 16. Four pastels and two watercolors exhibited at the 7th Annual Exhibition of Watercolors at the AIC.

MAY. Henrietta Whipple, 23 years old, and Lungren meet for the second time. Born Mary Henrietta Coflin on May 18, 1872, she lost her parents at an early age and was raised by her aunt and uncle, Mr. and Mrs. Edward Alexis Whipple, old friends of General Custer and his widow. Young Henrietta shared with Lungren an interest in the West and its Native American inhabitants.

OCTOBER 22 – DECEMBER 8. *The Cliff Dweller* exhibited at the AIC's 8th Annual Exhibition of Paintings and Sculpture.

DECEMBER 23–FEBRUARY 22. *Moonlight: Mojave Desert*, *On the Jump*, and *A Tusayan Princess*, all watercolors, exhibited at the 65th PAFA annual exhibition.

1896
The Snake Dance (illustration) exhibited at the NAD.

Utah granted statehood.

APRIL 16 – JUNE 7. Lungren exhibits 14 works, 9 watercolors and 5 pastels, at the AIC annual watercolor exhibition.

AUGUST 15. "Among the Moki Indians" published in *Harper's Weekly* (Vol. 40), with text by Hamlin Garland and illustrations by Lungren, including one that closely matches the composition of *The Snake Dance*, his largest and most ambitious work.

OCTOBER 20 – DECEMBER 6. *Afterglow — Through the Rocio* exhibited in the American Paintings and Sculpture Annual at the AIC.

1897
Harper & Brothers publishes *The Painted Desert: A Story of Northern Arizona* by Kirk Munroe with 20 Lungren illustrations.

1898
JANUARY 10 – FEBRUARY 22. *Thirst* exhibited at the 67th annual exhibition of the PAFA.

APRIL 2 – 23. *Red Buttes—The "Painted Desert"* (watercolor) exhibited at the BAC annual exhibition.

JUNE 15. Henrietta Whipple and Fernand Lungren marry at her home in New York.

1899
MARCH 13. At the invitation of the American Art Galleries in Madison Square South, Lungren presents an exhibition highlighting his most recent work, "Pictures and Studies of the Southwest." Included are *Thirst, On the Edge of the Painted Desert, Introspection, Rivers of Stone,* and Lungren's largest work, the unfinished *Snake Dance, Tusayan* (7' x 12').

APRIL. Lungren and "Nettie" sail for London, where they take up residence in Edward Square, Kensington West. The Lungrens remain in London for three years.

DECEMBER. The Pastel Society accepts Lungren for membership upon the recommendation of Joseph Pennel.

1900

FEBRUARY. A selection of Lungren's pastels set in London are included in the Pastel Society's second exhibition.

JULY 3. *In the Blue Arizona Night—Telling Fortunes* and *The Dim Trail—Cowboy Trailing Stock* are both included in the Royal Academy's annual exhibition. *The Dim Trail— Cowboy Trailing Stock* would eventually decorate Theodore Roosevelt's White House and remain in the President's collection until his death.

SEPTEMBER. The Walker Art Gallery, Liverpool, invites Lungren to participate in the Autumn Exhibition of Pictures and Sculptures. Lungren submits *London Bridge—The Homeward Tide*, *Picadilly Circus—Wet Evening*, and *Landing Stage, Liverpool—Landing of a Liner* plus two American landscapes, *The Painted Desert* and *Entrance to Black Canyon*.

NOVEMBER. Henry Solomon Wellcome invites the Lungrens to join him on a seven-month tour of Egypt.

1901

SPRING. Corporation Art Gallery, Oldham, shows the watercolor *London Bridge—The Homeward Tide* in the 12th Spring Exhibition. *Landing Stage, Liverpool*, a pastel, is shown at the Spring Exhibition of the City Art Gallery of Leeds. The Royal Academy includes *The Pony Express* in their annual exhibition.

JUNE. Returning from Egypt, Lungren arrives in London to discover his baggage ransacked and the majority of his pastels and sketches from the trip lost. A small number of works, shipped separately for inclusion in the third annual Pastel Society exhibition, escape damage. In addition to

Moonlight on the Desert, Arizona and *Trail of the High Place*, Lungren included several Egyptian scenes: *In Upper Egypt, Cheops and Cephren —Early Morning, The Light in the Desert, Egypt*, and *Sphinx Harmakis*.

AUTUMN. The 3rd Congress of the International Society of Sculptors, Painters, and Gravers includes a Lungren canvas.

SEPTEMBER 17. Railroad service to the South Rim of the Grand Canyon established making tourism and commercial development markedly easier.

NOVEMBER. The Lungrens return to America, taking up residency in New Jersey for a year.

1902

Owen Wister's *The Virginian* published by Macmillan.

JANUARY 20— MARCH 1. Lungren exhibits *Gebel Turah: Late Afternoon* and *In Upper Egypt: Evening* in the 71st annual exhibition of the PAFA. He shows the same two works at the BAC Annual, Akpril 5–26.

FEBRUARY. *Picadilly Near the Circus* exhibited in James D. Gill's 25th annual exhibition in Springfield, Massachusetts.

MARCH 17— MARCH 29. New York City's Macbeth Gallery presents "Some Phases of London When the Lamps are Lighted," an exhibition of 25 Lungren pastels. In the catalogue, William Macbeth describes Lungren as the first artist to discover New York streets and praises his masterful handling of pastel.

APRIL 22 — JUNE 8. In the 14th Annual Exhibition of Watercolors by American Artists at the AIC, Lungren exhibits 25 works including 5 Egypt and London pastels and 20 watercolors.

1903

Charles Lummis helps the Lungrens find a studio bungalow in Los Angeles at 201 W. 41st Avenue.

JANUARY 1— FEBRUARY 1. *Lower New York: Late Afternoon* exhibited in the NAD annual exhibition.

JANUARY 19 – FEBRUARY 28. Lungren exhibits six works from Egypt and London in the 72nd annual exhibition of the PAFA: *The Pool and Tower Bridge from London Bridge, Pyramids of Geizeh: Evening, Westminster Bridge and Clocktower, The Passing Train, Waterloo Bridge and Victoria Embankment*, and *Piccadilly Circus: Wet Evening*.

APRIL 4 – 25. *Piccadilly Circus* and *Waterloo Bridge* exhibited at the BAC annual exhibition.

NOVEMBER. The Lungrens tour the Southwest. In Flagstaff, they join William Allen White, the *Emporia* newspaper editor and publisher, and Dr. and Mrs. George A. Dorsey on a tour organized by Fred Harvey. Dorsey is an anthropologist and assistant curator at the Field Museum. The group proceeds to Albuquerque and then travels through New Mexico and Arizona, with stops at Navajo and Hopi villages. At the Grand Canyon, Lungren encouraged the group to hike into the canyon on Bright Angel Trail. The event, including a romantic description of Lungren leading Henrietta to the head of the trail blindfolded, was described by William Allen White in *McClure's Magazine* (Vol. 25).

NOVEMBER 12. Lummis founds the Southwest Society as a branch of the Archaeological Institute of America for the purpose of preserving the culture of the southwestern United States. The Society would later be instrumental in the formation of the Southwest Museum in Los Angeles.

1904
Stewart Edward White's *The Mountains* published serially in *McClure's Magazine* and as a book. Both formats feature Lungren illustrations.

SPRING. In the company of Joseph Lippincott, Lungren vacations in Yosemite Park and the High Sierra. He crosses Tioga Pass, seeing Mono Lake, the Owens Valley, and the lava beds of the Mojave.

SEPTEMBER 29. The *Inyo Register* reports that Fred Eaton and William Mulholland have arrived in the Owens Valley and are being shown around by Joseph Lippincott, regional engineer for the US Reclamation Service (the predecessor to the Bureau of Reclamation). Ultimately these three

would lead the building of the Los Angeles Aqueduct to redirect the water of the Owens Valley 250 miles south to Los Angeles. Lungren, an acquaintance of Lippincott and Mulholland, took a keen interest in the water project.

OCTOBER 27. IRT subway opens in New York City.

1905
Lungren exhibits 23 oils, pastels, and watercolors at Steckel Galleries, Los Angeles' first art gallery. A Western canvas is also included in the 1905 Congress of the International Society of Sculptors, Painters and Gravers.

1906
Grand Canyon Game Preserve created by President Theodore Roosevelt.

FEBRUARY. As guests of Stewart Edward White, the Lungrens visit Santa Barbara. Within a week, Lungren agrees to purchase land in the Pedregosa Tract and finds a temporary residence at the Harmer studio building in De la Guerra Plaza.

MARCH. The Lungrens take up residence in their temporary studio home. Sometime after moving to Santa Barbara, Lungren hosts his first public exhibition in this studio. On display are: *Thirst, The Inner Gorge of the River, Danger, The Enchanted Mesa, Twilight, Up in the Sierras, Picadilly Circus, Evening*, and other London scenes.

APRIL 18. Earthquake and fire destroy large portions of San Francisco.

1907
JANUARY. Charlotte Bowditch of Boston purchases *At the River, Grand Canyon*. She later purchased *In the Lava* and *The Crier, In Upper Egypt* (pastel) as well as watercolor studies for Lungren's *Snake Dance* painting.

SUMMER. Building continues on the Lungrens' Mission Canyon home, called La Casa Nichita after one of Fernand's nicknames for his wife, based on the names Lungren had used in a painting of the Grand Canyon, *Buttes, Magi and Nichi*.

92

DECEMBER 31. The Southwest Museum incorporated by Lummis and members of the Southwest Society.

1908
Henry Ford introduces the Model T.

The Grand Canyon becomes a National Monument for its cultural and geographic significance.

OCTOBER. Lungren first visits Death Valley.

1909
Upon receiving advice from his eye doctor to give his eyes complete rest, Lungren travels with Lippincott to inspect work in the Owens Valley. Against his doctor's advice, he continues painting throughout the summer.

1910
SPRING. Owen Wister and Lungren meet for the first time in Santa Barbara. Wister purchases the painting *Open Country*. The Wisters visited Santa Barbara several times in the ensuing years. Lungren and Owen Wister maintained a correspondence for many years.

1911
Arizona and New Mexico are granted statehood.

JANUARY. Henrietta Lungren returns to New York at the urging of Lungren and her doctor. During her absence Lungren travels to Death Valley.

FEBRUARY 5– MARCH 26. *Above the Timber Line: Snow-Squall in the High Sierras* exhibited at the 106th annual PAFA exhibition. Owen Wister had encouraged Lungren to submit some of his paintings. Both men were angered when the selection committee chose a mountain scene and rejected all the desert scenes.

JUNE. Fernand joins Henrietta in New York and escorts her back to Santa Barbara.

SUMMER. Lungren's *Rose Rock Canyon*, owned by Wister, is shown at the International Art Exhibition in Rome.

FALL. Lungren travels to Arizona for sketching and collecting Navajo blankets. On this trip he makes the difficult descent into Moon Canyon.

1913
NOVEMBER 5. The Lungrens attend the festivities as water from the Owens Valley first arrives in the San Fernando Valley.

1914
Moonrise on White Mesa, Surf After a Sou'Easter, and a Nile sketch exhibited in a temporary gallery at the Santa Barbara Normal School. Lacking a formal gallery space, Santa Barbara artists used the Normal School space for community exhibitions.

1915
FEBRUARY 20. The Panama-Pacific International Exposition opens in San Francisco. The American art galleries include Lungren's *In the Abyss*.

MARCH 20 – APRIL 25. *Au Café* exhibited in the 90th annual exhibition of the NAD.

JULY. Lungren and Owen Wister meet for the last time.

1916
NOVEMBER 2 - DECEMBER 7. *Rivers of Stone, Lava Flow in the Desert* exhibited at the AIC's Annual Exhibition of American Oil Paintings and Sculpture.

1917
House and Senate bills introduced to upgrade the Grand Canyon National Monument to a National Park under the jurisdiction of the recently established National Park Service. Both bills pass and are signed by President Woodrow Wilson in 1919.

NOVEMBER 11. Henrietta Lungren dies unexpectedly.

1919
Prohibition begins in the United States and lasts until the repeal of the 18th Amendment in 1933.

1920

JUNE 15. Civic and culturally minded members of the Santa Barbara community meet to begin organizing the Civic League, which would eventually merge with the Santa Barbara Community Arts Association.

AUGUST. The Civic League elects Lungren President of the "Festival Arts School Association" for the Santa Barbara School of the Arts. He is appreciatively credited as the founder of the school.

NOVEMBER. The Santa Barbara School of the Arts opens.

1922

Thomas Moran settles in Santa Barbara, taking up residence in a bungalow at 1821 Anacapa Street.

Lungren accepts the first Presidency of the newly organized local chapter of the American Indian Defense Association.

APRIL 24. SB Community Arts Association is chartered.

1924

JUNE. The Santa Barbara Art League is organized. In addition to Lungren, the charter members include Thomas Moran, an honorary member, and Edward Borein, Carl Oscar Borg, Belmore Browne, Dudley Carpenter, Colin Campbell Cooper, R. Cleveland Coxe, Ross Dickinson, Frank Morley Fletcher, John Gamble, Dan Sayre Groesbeck, Albert and Adele Herter, Eunice MacLennan, Clarence Mattei, William Otte, DeWitt and Douglas Parshall, and Lilia Tuckerman.

SUMMER. With Dr. Henry Perkins Moseley, Lungren makes a one-month visit to the Canadian Rockies.

1925

Lungren paints a 21' x 5' background depicting the Mojave Desert for a diorama of desert birds at the Santa Barbara Museum of Natural History.

SPRING. Lungren visits Utah.

MAY. Lungren opens a solo exhibition in the Art League galleries in Santa Barbara's Casa de la Guerra.

JUNE. An earthquake levels most of Santa Barbara. Lungren's adobe home, a material selected by Lungren for its resistance to fire, suffers considerable damage.

1926

After turning down a request from the Museum of the American Indian, Lungren donates a portion of his extensive collection of artifacts, primarily Native American, to the Santa Barbara Museum of Natural History. The remainder of his artifact collection was transferred to the Museum upon Lungren's death.

Thomas Moran dies in Santa Barbara.

SPRING. Fernand Lungren and Morley Fletcher sail to Scotland and England. After returning to the States, Lungren traveled back across the continent via the Canadian Rockies.

1928

According to biographer John A. Berger, Registrar of the Santa Barbara School of the Arts, Lungren completes his last Death Valley painting.

Lungren completes a second background for a mountain sheep diorama at the Santa Barbara Museum of Natural History. This 22' x 7' background features a view of Death Valley from Dante's Point.

SPRING. *Sunset Cliffs* and *Red Cliffs* exhibited in the Annual Spring Salon at the Springville High School Art Gallery in Springville, Utah. Lungren participated in the Springville exhibition for three consecutive years.

1929

SPRING. The Springville High School Art Gallery shows *New Snow* and *In The High Sierras* at the annual exhibition.

1930

SPRING. *Sand Dunes* and *The Prospector* shown at the Springville High School Art Gallery.

FALL. Lungren visits the Owens Valley with Brett and Beulah Moore.

OCTOBER 15. *In the Abyss, Desert Dawn,* and *The Hour in Violet* exhibited at the opening of the Faulkner Memorial Art Gallery, a new wing of the Santa Barbara Public Library.

1931

SPRING. Despite failing health, Lungren again visits Death Valley with friends.

FALL. Mrs. Joseph Parsons commissions a desert painting of Lungren's choice. *Desert Evening* was the last new desert composition Lungren was to undertake. Parsons eventually donated the work to the Addison Gallery of American Art at Phillips Academy, Andover, Massachusetts.

1932

MAY. Lungren begins reworking *Death Valley—Morning* and *Death Valley—Dante's View* and makes one last trip to Death Valley, alone.

NOVEMBER 1. During a trip to northwestern Nevada with Ed Parker, Fernand experiences heart trouble. Upon returning to Santa Barbara, he is bedridden for four days.

NOVEMBER 9. Fernand Harvey Lungren dies, four days before his 75th birthday. His ashes are mixed with Nichi's and taken by Ed Parker and Herman Eddy to a ridge north of Death Valley, overlooking Benton. His will provides for the transfer of his painting collection to Santa Barbara State Teachers' College and the remainder of his artifact collection to the Museum of Natural History.

1933

FEBRUARY 11. President Herbert Hoover signs the proclamation creating Death Valley National Monument.

1934

SUMMER. Santa Barbara State Teachers' College, a predecessor institution to the University of California, Santa Barbara, holds a Memorial Exhibition of Lungren's works drawn from the bequest.

2000

MAY 2. *Afterglow in the Desert: The Art of Fernand Lungren* opens as the inaugural exhibition in the newly renovated University Art Museum, University of California, Santa Barbara.

University Art Museum Staff

Hallie Anderson, *Outreach Coordinator*

Marla C. Berns, *Director*

Elizabeth A. Brown, *Chief Curator*

Peggy Dahl, *Assistant to the Director*

Rollin Fortier, *Preparator and Webmaster*

Cody James Hartley, *Curatorial Assistant*

Kurt G.F. Helfrich, *Curator, Architecture &*
Design Collection

Sharon Major, *Publicity Coordinator*

Paul Prince, *Designer*

Sandra M. Rushing, *Registrar*

Victoria Stuber, *Business Manager*

Kerry Tomlinson, *Assistant Registrar*

Catalogue Design:	Ginny Brush Brush & Associates
Printing:	Ventura Printing
Edition:	2500
Typefaces:	Fairfield Light, Medium News Gothic
Digital Imaging:	Wayne McCall & Associates
Photography:	Wayne McCall Scott McClaine, p. 24 Jane Dini, p. 43 Courtesy Hirschl & Adler, p. 30 Courtesy The Art Insitute of Chicago, p. 31